FRANCIS BACON

MARTIN HAMMER

PHAIDON · FOCUS

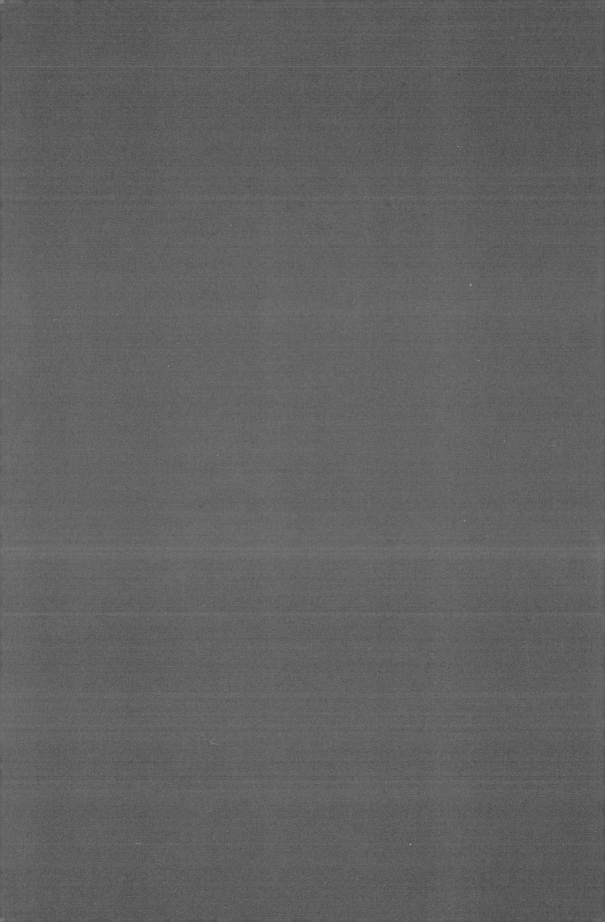

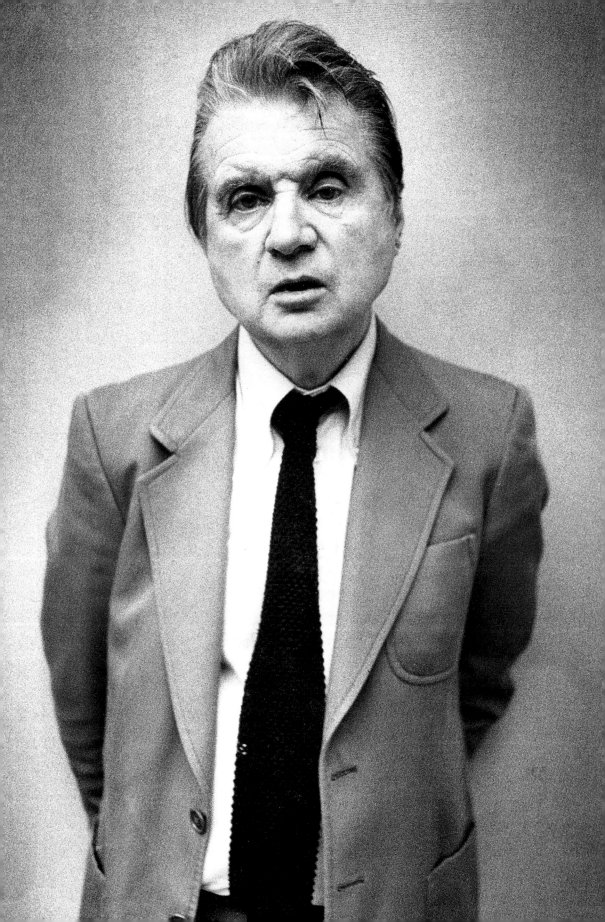

A MODERN MASTER

The art of Francis Bacon (1909–1992) remains compelling and powerful today, still speaking to viewers remote from the bleak post-war world in which his pictures were first exhibited. Crucially for its wide appeal, Bacon's aesthetic vision was figurative rather than abstract, possessing a very immediate visual impact. His paintings suggest some darker sense of the human condition beneath everyday life, conveyed especially by the alarmingly distorted physiognomies and bodies. While Bacon's effects look uncompromisingly modern, they also acknowledge tradition and the past, and so seem to set themselves at odds with the more esoteric forms of avant-garde art, such as Minimalism and Conceptualism. Indeed, his pictures defy the very idea that painting itself is dead or outmoded. In common with that of numerous other artists in recent decades, Bacon's work also utilizes elements from photography and film. Yet in his case such allusions are not just recycled, as Andy Warhol (1928–1987) did, but transformed into visceral pictorial statements.

Bacon rose to international fame as the most original British painter of his day, inspiring successive generations of artists. Major retrospectives took place at the Tate Gallery in London (an unprecedented two during the artist's lifetime, in 1962 and 1985), in Paris (1971), New York (1975) and elsewhere. The French capital, where he spent considerable time in later life, was especially meaningful to Bacon. He ultimately saw himself as the heir to a tradition of experimentation and uncompromising individualism handed down by such European forebears as Edgar Degas (1834–1917) and Pablo Picasso (1881–1973). Like these artists before him, Bacon focused heavily on the human figure, whereas many of his English contemporaries hearkened back nostalgically to landscape themes and a native Romanticism. In the decades since his death, Bacon has joined the ranks of Picasso, Mark Rothko (1903–1970), Warhol and others as a blue-chip modern 'Old Master'.

Bacon's creativity is inextricably tied to the legend of the artist's charisma and colourful, bohemian existence. Several recent biographies emphasize his exposure to an unremittingly violent and traumatic period of world history; his overt masochistic homosexuality; a turbulent love life; and addictions to drinking and casino gambling. Yet, as with Picasso, the challenge is to grasp the pictorial intensity and existential force of Bacon's achievement, rather than reducing it to mere autobiographical illustration.

◄ Francis Bacon in 1990.

CONFRONTING BACON

THE INVITATION TO LOOK

In 2008–9, a grand centenary show travelled to Tate Britain, London, the Museo del Prado, Madrid, and the Metropolitan Museum of Art, New York – an immensely prestigious itinerary showing that Bacon has posthumously become even more of an artistic phenomenon. At auction, Bacon's pictures consistently fetch eight-figure sums; and one of the world's most conspicuous contemporary artists, Damien Hirst, has signalled an allegiance to Bacon by collecting his work and rendering it as pastiche. David Sylvester's volume of interviews with Bacon remains one of the most widely read in the literature on art.

[1]

► FOCUS (1) THE SYLVESTER INTERVIEWS, P.16

However, fame and familiarity do not necessarily make works of art more accessible. With Bacon, more perhaps than other major artists, the frequently repetitious commentary by critics and the rehashed quotes from interviews with the artist can inhibit viewers from immersing themselves in their own visual sensations and imaginative responses. Therefore, before we review his work and career chronologically, consider two pictures that often hang next to one another in the Scottish National Gallery of Modern Art in Edinburgh. They were created some thirty-five years apart, and suggest important under-lying continuities within Bacon's evolving aesthetic. The first was made a few months after the exhibition at the Lefevre Gallery, London, in April 1945 that effectively launched the artist's career; the second dates from a year or so before his death in 1992.

Together, the paintings encapsulate the trajectory of Bacon's artistic development. *Figure Study I* seems to be a montage of fragmentary and disconnected elements – an overcoat, a hat, flowers and more abstract background details – that appear to have crystallized within an improvised painting process, obscuring discarded ideas and layers of paint. By contrast, *Study for a Portrait, March 1991* is larger in scale, and far more legible in its description of a particular, anatomically coherent individual. The thinner paint surface suggests that Bacon started working with a clear idea about the final com-position. The early picture seems to have been an exploratory struggle for the artist, whereas the later one appears to have come to him more easily and looks relatively deft. The yardstick is Bacon's own: 'I think that the best works of modern artists often give the impression that they were done when the artist

[4]

[6]

◄ Bacon in his London studio, 1962.

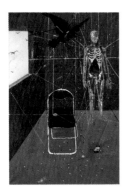 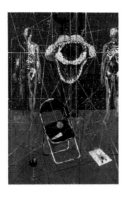 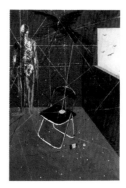

1
Damien Hirst (b.1965)
Insomnia, 2008
Oil on canvas
Triptych, each panel:
251 × 175.5 cm
(98 ¾ × 69 in)

was in a state of unknowing ... when you get to the late analytical-cubist works, there's a totally mysterious relationship to reality which you can't begin to analyse, and you sense that the artist didn't know what he was doing, that he had a kind of rightness of instinct and that only instinct was operating.'

Yet affinities between the two paintings are equally striking, beyond the coincidental similarity of background colour. In both, that bright backdrop is played off against muted passages in the figurative imagery. The simplicity of the background is pitted against areas of complex texture and detailing, while its emphatic flatness contrasts with strong indications of spatial depth and three-dimensional form in the figure and the objects. Likewise, the paint is smoothly applied in some areas, but smudged or blurred in others, just as the degree of focus and clarity of definition varies considerably as one scans the compositions. In the earlier picture, there is no apparent logic to the juxtaposition of outdoor garments and flowers, which are worn or held by a figure who seems to have vanished, while in the late portrait the figure seems comparably unconnected to the tripod-like form in front of him. In each picture there are, disconcertingly, indications of both interior and exterior spaces.

What, then, does it all signify? Are there underlying meanings here to discover? Or are the pictorial ambiguities meant rather to spark a process of subjective interpretation? Confronted by the originals rather than reproductions, one notices the artist's consistent preference for glazing his pictures and using old-fashioned gilded frames, as though suggesting ties, possibly tinged with irony, between himself and the Old Masters. The consequence is that we literally see ourselves and others reflected in the works, just as we are in a sense thrown back on ourselves when we try to comprehend the perverse contrasts and oppositions the pictures contain. When we look hard at Bacon, what we see fails to meet expectations of clear pictorial or thematic coherence. This in itself is one further element in the widespread appeal of his paintings – we cannot just work them out, and then walk away.

PARADOX

Like the pictures, Bacon's thought processes and their verbal expression persistently cultivated paradox. His work, he declared, involved a 'kind of tightrope walk between what is called figurative art and abstraction'. He was seeking in his paintings an 'ambiguous precision' and a 'very ordered image', which nevertheless 'comes about by chance'. 'I've increasingly wanted,' he remarked on one occasion, 'to make the images simpler and more complicated.' An effect of spontaneity was essential, yet its apparent opposite also comes to the fore when Bacon talks about the presentation of the pictures:

> The frame is artificial and that's precisely why it's there; to reinforce the artificial nature of the painting. The more the artificiality of the painting is apparent, the better, and the more chance the painting has of working or of showing something. That might seem paradoxical, but it makes perfect sense in art: one achieves one's goal by using the maximum of artificial means, and one succeeds much more in doing something authentic when the artificiality is perfectly obvious. Take the example of Greek or Classical poets; their language was very artificial and highly stylized. They all worked within constraints, and yet it's precisely in doing so that they produced their greatest works which give us, when we read them, that impression of freedom and spontaneity.

Bacon's fascination with opposites held in suspension went beyond the aesthetic realm. For instance, he was well aware of his own capacity to be 'optimistic and totally without hope', an attitude he characterized as 'exhilarated despair', rooted in the sense that 'if life excites you, its opposite, like a shadow, death, must also excite you'. The artist derived endless satisfaction from the perverse irony of the line, 'The reek of human blood smiles out at me,' from a speech by Clytemnestra after killing her husband,

2
Illustration from K. C. Clark,
Positioning in Radiography, 1939

King Agamemnon, on his return from Troy, which Bacon had encountered in translation in a 1942 book about the ancient Greek tragedian Aeschylus. The suggestive ambiguity is matched by the fusion in Bacon's own work of strong, disquieting content and decorative appeal. The artist even chose to live and work in a state of what he called 'gilded squalor'. Such attitudes were redolent of the post-war intellectual climate dominated by existentialist philosophy.

► FOCUS ② BACON AND EXISTENTIALISM, P.18

CONSTANTS

Paradox is not the only deeply rooted constant in Bacon's *oeuvre*. He was also compulsive about scale (a large percentage of his pictures are either around 200 × 150 cm [78.7 × 59 in] or else 35 × 30 cm [13.8 × 11.8 in]); about details of presentation such as the gilt frames and glazing; a range of formal and technical devices (rectangular linear boxes, often termed 'space frames', enclosing the figures, or blobs of white paint ostensibly thrown at the canvas); and about the overall design of his pictures, single figures usually being positioned centrally within interior spaces. He often combined three such images into triptychs, especially during his final three decades, their compositions orchestrated to reinforce the overall symmetry of the format.

Further, Bacon operated to a considerable degree with a well-established set of themes. He would frequently apply himself in quick succession to a cluster of works devoted to the same basic leitmotif, which might or might not be exhibited together as a series, such as the *Heads* (1949), the popes (which came in several mini-series produced over more than a decade), the *Men in Blue* (1954), and the dogs and sphinxes from around the same time. [5] The Van Gogh variations exhibited together in 1957, the accumulated portraits of several particular individuals such as Lucian Freud (1922–2011), the Crucifixions, and the many distillations of copulating men from 1953 onwards – all equally comprise variations on themes. The fact that so often his pictures are entitled 'Study' for something indicates that Bacon felt he was forever not quite achieving some ideal or definitive image that existed in his imagination. 'One's always hoping,' he remarked, '... to paint the one picture which will annihilate all the other ones, to concentrate everything into one painting.' This sense of frustration caused him to rework or even destroy many canvases – a practice for which he became famous from the late 1940s onwards. Otherwise, Bacon consistently preferred to accompany his pictures with deadpan titles (the more descriptive ones tended to be given by his gallery, for identification or commercial purposes). He commented, characteristically, 'I really want to keep them as anonymous as possible ... people can read what they like into them.'

Other continuities are evident in Bacon's underlying creative process. It mattered to him that this felt very open: 'I don't want the work to be hazy, but I work in a kind of haze of sensations and feelings and ideas that come to me and that I try to crystallize.' One of the earliest accounts, by critic Robert Melville, attributed an almost visionary motivation to Bacon's method of working directly onto the canvas with big brushstrokes:

> Swiftness of execution has become an essential of his creative process, for he has to re-create visualizations that are so tenuous that they can only be seen, so to speak, out of the corner of the mind's eye. He has to snatch, as it flashes across his mind, the movement of a head, the sliding of an inert body, the passage of a scream ... His concern is with the power to make images rise up suddenly on his canvas, as a sorcerer might summon up spirits, wanting nothing of them except their emergence at his bidding.

The idea of Bacon as a shaman-like creator, motivated by pure instinct, pervades the critical literature. Yet in reality he generated that 'impression of freedom and spontaneity' within strict parameters. He consistently started by sketching out on the canvas the configuration of an animate creature, usually a figure, within a spatial setting. In its most basic form, this is what we encounter in his known drawings and in the unfinished pictures left in his studio. Such a skeletal template acted as the springboard for an improvisational process that might involve the complete reworking of the composition, sometimes several times in early works, or later the insertion of spontaneous-looking painterly marks and only quite minor revisions to the original idea. Bacon, like many other artists (or indeed the jazz musicians he admired), required a strong infrastructure of habit, routine and repetition

3
John Deakin (1912–1972)
Photograph of Henrietta Moraes,
folded and overpainted by Bacon,
c.1963
Black-and-white photograph on paper
20.7 × 24.9 cm (8 ⅛ × 9 ¾ in)
Dublin City Gallery The Hugh Lane

to facilitate his intuitive behaviour and decisions. As the critic Sam Hunter acutely remarked after spending time with Bacon in the summer of 1950: 'Behind the deceptive effect of spontaneity is a rigorous personal discipline of vision and a long period of trial and error in sorting and choosing relevant images, and of learning how to marry vision and technique.' Bacon's picture-making procedures exemplify a notion of 'structured spontaneity' that has relevance to vast tracts of human activity. In his book *Blink* (2005), about the role of instant judgements in our encounters with people or situations, Malcolm Gladwell argues that often spontaneity is most effective when it is meticulously rehearsed in terms of underlying principles and strategies, and that 'truly successful decision-making relies on a balance between deliberate and instinctive thinking'.

One such recurrent strategy for Bacon was the way in which he adapted ideas from photographs when starting or evolving an image, though these points of departure became distorted and transmuted into emphatically painted surfaces. Art historians have identified many springboards for Bacon's iconography, from such varied sources as medical textbooks; volumes about wild animals and spiritualism; the pioneering visual encyclopaedia of human and animal movement by photographer Eadweard Muybridge (1830–1904); miscellaneous art books; Nazi propaganda images; shots of boxing and bullfighting; photographic portraits of mutual friends taken for the purpose by his friend John Deakin; and, increasingly in later life, reproductions of his own pictures. Several appropriations from photography might end up combined in a single canvas. Bacon often relished juxtapositions where the soft, vulnerable forms of the human body are played off against geometric or regular grid formations, as in Muybridge's studies of the body, or against hard-edged scientific and medical equipment, as in the illustrations to K. C. Clark's textbook *Positioning in Radiography*. We know [2] too that he referred to such source material while painting (rather than just working from memory). The evidence includes the accounts of sitters who recalled Bacon, somewhat alarmingly, consulting photos of animals while depicting their likenesses; the spattering of paint on pages in books or sheets torn from magazines that lay exposed while he worked; and also his practice of manipulating and folding images, done in some cases at least to make them easier to hold up in front of him while painting. Working directly from photographs was another of the many constants in the creative process [3] that generated Bacon's paintings. Yet the repetition of images and methods certainly did not produce a repetitive *oeuvre*, or not at any rate until the artist's final years.

► FOCUS (3) PHOTOGRAPHIC SOURCES, P.20

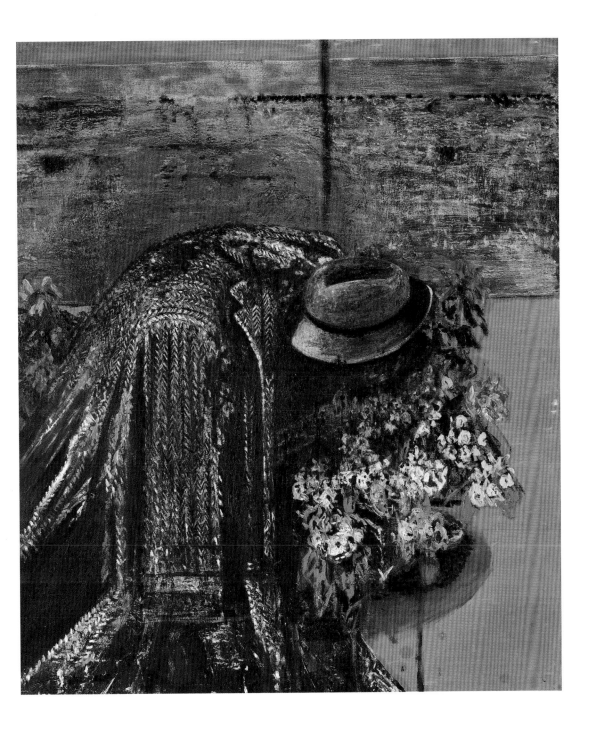

4
Figure Study I, 1945–6
Oil on canvas
123 × 105.5 cm
(48 ½ × 41 ½ in)
National Galleries of Scotland, Edinburgh

5
Sphinx III, 1954
Oil on canvas
198.7 × 137.1 cm
(78 ¼ × 54 in)
Hirshhorn Museum and Sculpture Garden,
Smithsonian Institution, Washington, DC

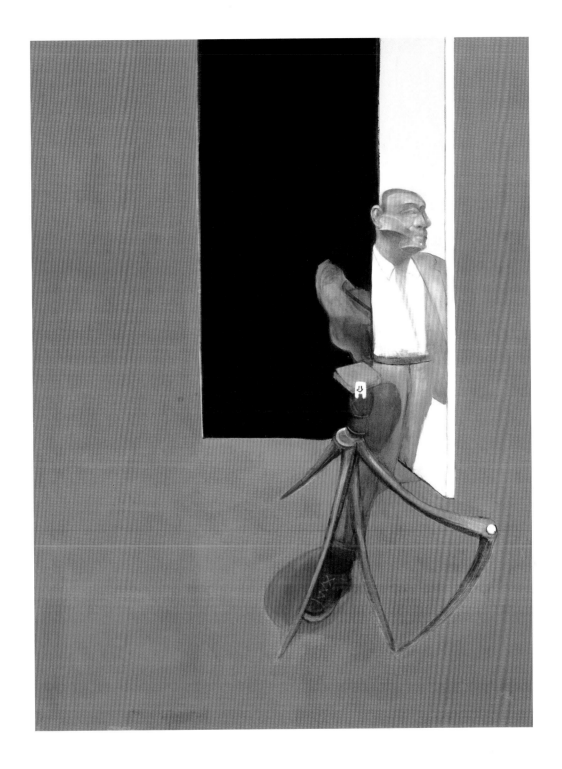

6
Study for a Portrait, March 1991, 1991
Oil and pastel on canvas
198 × 147.5 cm
(78 × 58 in)
National Galleries of Scotland, Edinburgh

FOCUS ①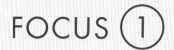

THE SYLVESTER INTERVIEWS

Nowadays the presentation of contemporary art in catalogues or the media is usually dominated by interviews with the artist. Bacon belonged to the first generation to experience and foster this phenomenon. His published conversations with David Sylvester [7] have certainly had a profound impact on how his work is understood.

The two men got to know one another around 1950 and, over the years, prospered together as respectively the leading painter and critic on the British art scene. More than anyone, Sylvester was responsible for introducing the post-war work of Alberto Giacometti (1901–1966) to Britain. In parallel, the critic produced some important and highly committed articles on Bacon's early painting. He curated several exhibitions and eventually wrote a general survey, *Looking Back on Francis Bacon* (2000). But the most significant product of their friendship and collaboration was the famous book of interviews, first published in 1975 and subsequently expanded. It has never been out of print, has been translated into many languages, and is one of the best-selling publications in the literature on art. The conversations revolved around several themes: Bacon's sense of the autobiographical roots of his art and his view of human beings as creatures dominated by animal instincts and desires; the strong role of chance and improvisation in making pictures; and the painter's belief in the expressive impact that visible marks and paint texture can have on the viewer's nervous system, as opposed to more illustrative and narrative approaches to painting that primarily address the rational intellect, and also in contrast to the smooth anonymity and descriptive nature of photography.

The interviews succeed because Bacon was naturally articulate, opinionated and engaging. For his part Sylvester was adept when talking to artists at conveying his enthusiasm for their work, at tactfully probing their intentions and attitudes, and at editing the resulting material on tape into coherent publications that still sound like spontaneous conversations. Many artists were prompted by Sylvester to say particularly illuminating things, and Bacon was no exception.

Nevertheless, the artist's vivid formulations can serve to limit and even inhibit what viewers are able and willing to see in the actual pictures. Bacon had a very clear view about his art, working methods, sensibility and the key components in his biography, and could be dismissive about other artists as well as interpretations of his work that seemed too fixed. Moreover, Sylvester was a personal friend as well as a fan, so had doubtless heard it all before and was not going to challenge Bacon to be more precise, factual, detailed or frank about, for example, his subjects, influences and techniques. It suited both men, in the years of Bacon's greatest fame, to present him as a latter-day Old Master, who took his bearings from Rembrandt, Velázquez, Michelangelo and so on, and had picked up the torch of figurative modernism from Picasso. For all their readability and the many insights that they give into Bacon's art, the interviews need also to be viewed as high-class propaganda.

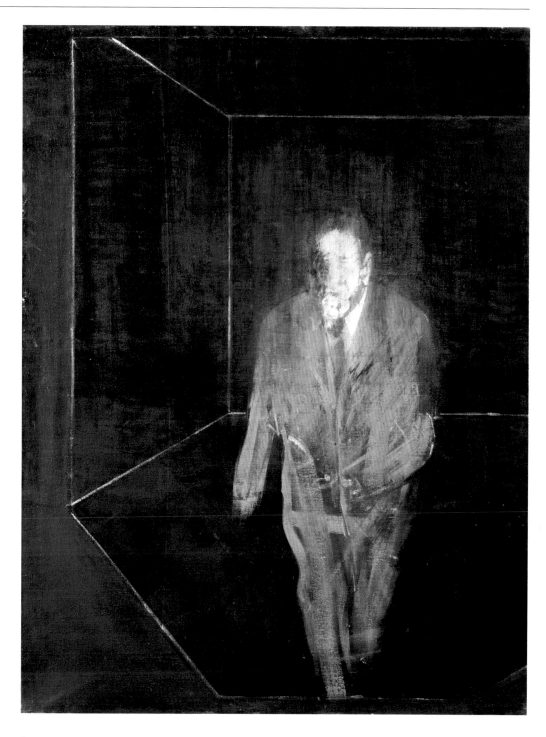

7
Untitled (David Sylvester Walking), c.1954
Oil on canvas
151.1 × 116.8 cm (59.5 × 46 in)
Private collection

FOCUS ②

BACON AND EXISTENTIALISM

Bacon's career after World War II coincided with the burgeoning of existentialism, a term describing a highly technical philosophy as well as a more widely diffused way of thinking about life, adopted especially by younger generations – the vogue was comparable to that more recently for postmodernism. For Bacon and fellow creative and intellectual figures in Britain, existentialism meant above all the writings of Jean-Paul Sartre (1905–1980) and Albert Camus (1913–1960), which emanated from Paris but were soon translated and extensively read elsewhere. Their novels and philosophical reflections raised searching questions about the nature and purpose of human existence, in the shadow of World War II and the Holocaust. How could one any longer believe in the myths of social progress or religious salvation? The only credible reality was the subjective experience of the solitary individual, and his or her capacity to find fulfilment through the decisions he or she is constantly making about personal actions and values. For Sartre, this general truth was encapsulated in the freedom and spontaneity cultivated by artists like Picasso and particularly his friend Alberto Giacometti, a former Surrealist whose new, more descriptive sculpture (initially modelled in plaster) Sartre interpreted in a vivid catalogue essay when it was exhibited in 1948. In common with Bacon, Giacometti focused insistently on the figure, and occasionally on the scream that evokes a state of existential anguish [8]. The space frame, which implies a fundamental human isolation and/or entrapment [9], is another common denominator of the work that the two artists produced on either side of 1950.

Bacon's artistic philosophy had a decidedly existentialist tone, suggesting he was responding to ideas that were in the air. In 1952 he was quoted as saying, 'I would like my pictures to look as if a human being had passed between them, like a snail, leaving a trail of the human presence and memory traces of past events, as the snail leaves its slime.' In later interviews, he stated, 'I think of life as meaningless; but we give it meaning during our own existence. We create certain attitudes which give it a meaning while we exist, though they in themselves are meaningless, really.' Making a good picture, like conducting an authentic life, entailed improvisation, a 'taking advantage of what happens when you splash the stuff down'. Given that it had lost any clear social function, 'art has now,' declared Bacon, 'become completely a game by which man distracts himself.'

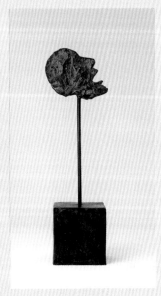

8
Alberto Giacometti
(1901–1966)
Head on a Rod, 1947
Bronze
Height: 59.7 cm (23 ½ in)
including bronze base:
16 × 15 × 15 cm
(6 ¼ × 6 × 6 in)
The Museum of Modern
Art, New York

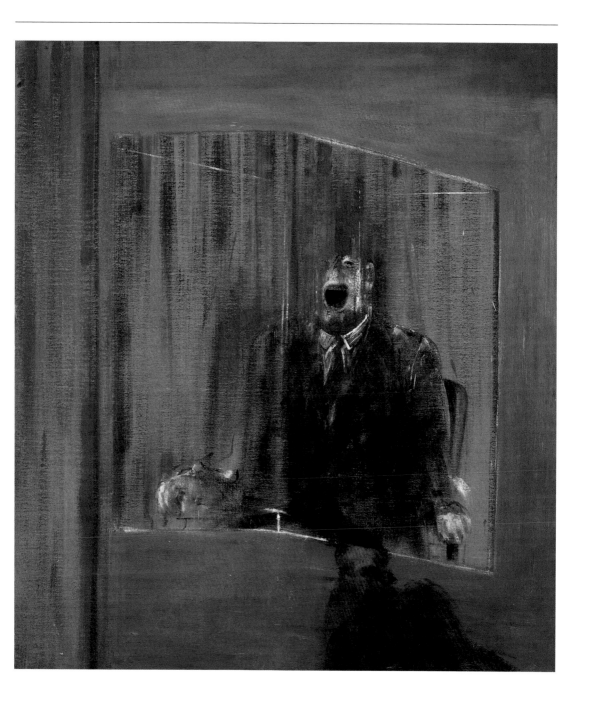

9
Study for a Portrait (Man in a Blue Box), 1949
Oil on canvas
147.5 × 131 cm (58 × 51 ½ in)
Museum of Contemporary Art, Chicago

FOCUS ③

PHOTOGRAPHIC SOURCES

We know that Bacon compulsively hoarded photographic images of many kinds, as recorded by a visitor to his work space as early as 1950 [12]. Eventually they littered the floors and walls of his various studios. Moreover, specific photographic sources can be pinpointed in a significant number of his paintings. An early example is *Figure in a Landscape* [11], where the setting derives from a photograph of a buffalo in the volume *Stalking Big Game with a Camera in Equatorial Africa* [10] – though the animal itself is replaced by a sinister, suited presence.

Bacon was not the first to realize that this relatively new medium of representation had fundamentally changed the terms of reference for painters. Indeed, since the mid-nineteenth century artists had felt compelled to reckon with photography, either by doing things that the new method of representation could not do (such as capturing the fleeting moment and using vivid colour, as in Impressionism, and exploring abstraction in the twentieth century), or alternatively by exploiting and emulating the new view of reality that it presented. Many artists, from Gustave Courbet (1819–1877) onwards, have surreptitiously used photography as a storehouse of motifs, a ready alternative to drawing from life. Others – from the English Impressionist painter Walter Sickert (1860–1942) in the inter-war period through to more recent figures such as Gerhard Richter (b. 1932), Chuck Close (b. 1940) and Luc Tuymans (b. 1958) – have overtly acknowledged photographs as a basis for their compositions, while also asserting the painted mark applied to canvas as the vehicle through which such references are filtered.

Bacon fits to some degree into both of these traditions. He admired Sickert and even acquired one of his paintings. But he was also distinctive in his willingness to transform and even subvert the photographic images he started with in the process of making his paintings, to the point that identifying the artist's sources requires detective work. Bacon's reinterpretations and distortions of those sources are the counterpart to his highly subjective responses to certain pictures. He was always, he remarked, 'haunted' by photographs, which most of the time he found 'very much more interesting than either abstract or figurative painting': 'It's the slight remove from fact, which returns me onto the fact more violently ... And photographs are not only points of reference; they're often triggers of ideas.' For Bacon, contemporary experience was thoroughly infused by the image domain of lens-based media, given that 'one's sense of appearance is assaulted all the time by photography and by film'. Any painting worth its salt, he felt, was bound to emulate, even compete with, the powerful, immediate and highly suggestive effects that these modern media had launched upon the world.

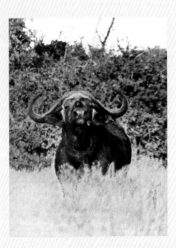

10
Plate from Marius Maxwell's *Stalking Big Game with a Camera in Equatorial Africa*, 1924

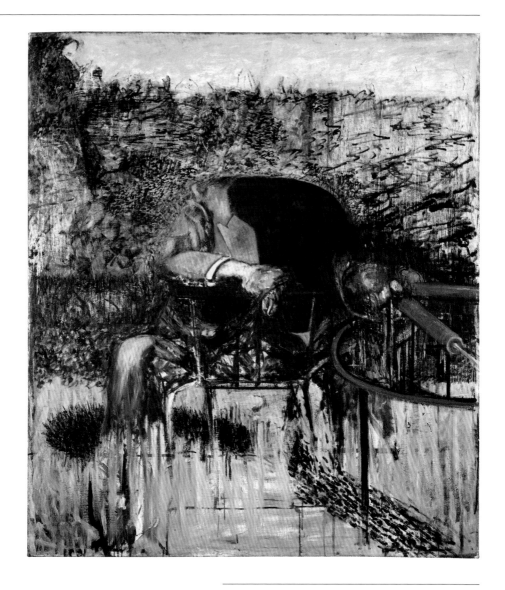

11
Figure in a Landscape, 1945
Oil on canvas
145 × 128 cm (57 × 50 ½ in)
Tate, London

Painted at the end of the war, when joy
and relief were tinged with horror, *Figure
in a Landscape* subverts the connotations
of informal portraiture and the natural
world. The colours are dark and drab; the
brushwork is scrubby; the figure has lost its
features and acquired a metallic framework
seemingly with microphones or a machine
gun attached.

12
Montage of
photographic
material
from Bacon's
studio, 1950
Photograph
by Sam Hunter

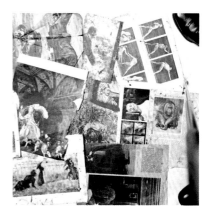

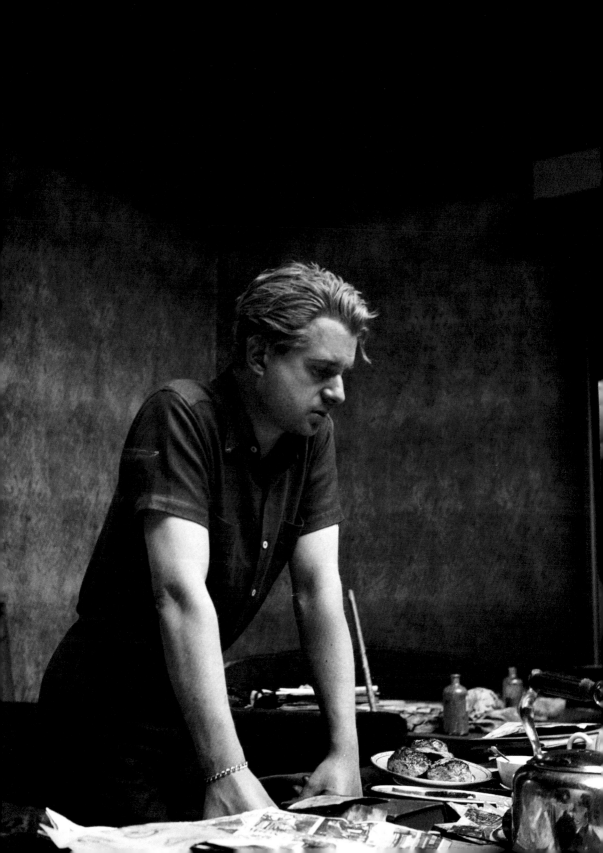

FORMATION, 1920–54

BEGINNINGS

[31]

Bacon believed that his career as a painter properly began in 1944 with *Three Studies for Figures at the Base of a Crucifixion*: a triptych of disquieting, monstrous, semi-human and semi-animal creatures, arrayed against orange backdrops with minimal indications of a setting. He exhibited the work the following April, alongside *Figure in a Landscape*, and often included it in retrospectives as the first picture in which he recognized his artistic identity. A subsequent burst of creativity culminated in Bacon's remarkable *Painting*.

[11]

[42]

► FOCUS (4) PAINTING, 1946, P.50

Unfortunately, we know remarkably little about Bacon's life and artistic activity before this point. He was born in Dublin on 28 October 1909 into a fairly wealthy English Protestant family, which belonged to the Anglo-Irish ruling class in a country still united under British rule. The Bacons moved between Ireland and England, his father a former army officer, now earning his living as a racehorse trainer. Their life was disrupted by the political turmoil and violence that eventually resulted in the formation of an independent Irish state. Bacon always felt that his youthful experiences left him with a heightened awareness of life's darker side, further compounded by the events that he subsequently witnessed: the Spanish Civil War, World War II, the atomic bomb, revelations of the horrors of the Holocaust, and the many post-war struggles for independence from colonial powers, not to mention the acute anxieties associated with the Cold War.

What he felt about current affairs at the time, as opposed to in hindsight, is completely unknown. There are hardly any contemporary documents or photographic records from the late 1920s onwards to indicate who Bacon knew, where he went, what he read and how he occupied himself. There is no evidence that he received an artistic or any other post-school education. We know that when he was about twenty he visited Berlin and Paris, discovering the work of modern film directors such as Sergei Eisenstein (1898–1948) and painters like Picasso, as well as finding outlets for his homosexuality. Soon afterwards London became his base. As early as 1930 he staged an exhibition of modernist rugs and tubular steel furniture, which attracted some notice and commissions. His first important artist friend was the Australian Roy de Maistre, a minor figure who taught him to use oil paint, and also shared the interest in everyday press photography that seems to have overtaken Bacon in

[28, 14]

[13]

◄ Bacon in his London studio, 1950.

13
Roy de Maistre (1894–1968)
Portrait of Eric Hall
Oil on canvas
91 × 71 cm (36 × 28 in)
Private collection

the late 1930s. During this period Bacon occasionally exhibited in group
shows, without much success or consistency of approach. He survived
financially by working as a gentleman's valet (probably a euphemism for
a male prostitute) before meeting Eric Hall, a wealthy businessman and local [13]
politician who, by the artist's own account, expanded his horizons, and
supported and encouraged his creative activities. Several pictures that survive
in the original or thanks to old photographs reveal a strong attraction to
Crucifixion imagery, although Bacon seems to have always been a committed [29]
atheist. Others indicate an interest in the organic, highly charged distortions
of the human form that characterized Picasso's contemporary output. Overall
the works are a mixed bag, and had Bacon been killed during the Blitz, like [30]
many of his fellow Chelsea residents, he would probably have disappeared
into historical oblivion.

14
Bacon's showroom at
17 Queensberry Mews West,
London, photographed for an
article in *The Studio* magazine
titled 'The 1930 Look in British
Decoration', with tubular steel
furniture and modernist rugs
of his designs

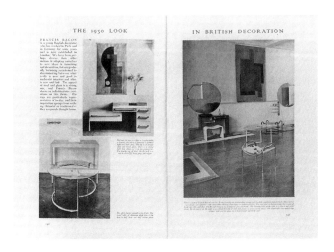

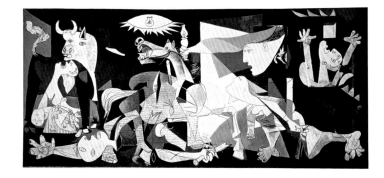

15
Pablo Picasso
(1881–1973)
Guernica, 1937
Oil on canvas
349 cm × 776 cm
(137 ½ × 305 ½ in)
Museo Nacional
Centro de Arte
Reina Sofía, Madrid

BREAKTHROUGH

[31]

[29]

In certain respects, *Three Studies for Figures at the Base of a Crucifixion* was an extension of earlier concerns, as can be in seen in *Crucifixion* of 1933. Still, the impulse to make this triptych, and to start painting again after what was evidently a long hiatus, seems to have arisen from the experience of living through the Blitz and witnessing in a less direct fashion the appalling consequences of Hitler's ambitions to control Europe, ridding the world of Jews and communism. Bacon volunteered for a time as an air-raid warden but had to give up because of his lifelong asthma. He subsequently alternated between the country and London, evidently using the time he now had on his hands to develop an art that distilled the tragic mood and violence of the times.

[15]

His interest in Picasso was doubtless reinforced by a London exhibition of *Guernica* and related works in October 1938, which had vividly demonstrated how art could be both modern and a passionately stirring comment on the physical and psychological impact of contemporary warfare, as inflicted on ordinary civilians as well as armies. In his triptych Bacon also derived inspiration from a strand in Picasso's work around 1929–30 in which extreme defor-

[16]

mation of the female anatomy is allied to emphatically sculptural volumes.

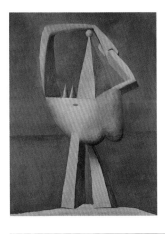

16
Pablo Picasso
Nude Standing by the Sea, 1929
Oil on canvas
129.9 × 96.8 cm (51 ⅛× 38 ⅛ in)
The Metropolitan Museum of Art,
New York

17
Illustration from Baron von Shrenk-Notzing,
Phenomena of Materialisation, 1920

If Picasso was one key point of reference for *Three Studies*, another was the diverse range of photographic material that had by now become an obsession for Bacon, informing several details of the work. Thus references to the human body are interwoven with forms inspired by picture books about wild animals. The head of the left-hand hybrid creature is known to derive from an obscure illustrated tome about spiritualism and ectoplasms, while the bandage in the central panel is adapted from a reproduction of *The Mocking of Christ* by Matthias Grünewald, a German Renaissance masterpiece by the creator of the great *Isenheim Altarpiece*. Another suggestion is that the schematic background settings refer to the classicizing architecture erected in Berlin and Nuremberg, mostly based on designs by Hitler's favourite architect, Albert Speer (1905–1981). This certainly fits in with Bacon's use in other works of features drawn from Nazi propaganda, as well as his comment that the real subject of the triptych was the Furies (otherwise known as the Eumenides) from Greek tragedy. He stated that the work would ideally have

[31]

[17]
[18]

[20]

18
Matthias Grünewald (1470–1528)
The Mocking of Christ, 1503–5
Oil on wood
109 × 74.3 cm (43 × 29.3 in)
Alte Pinakothek, Munich

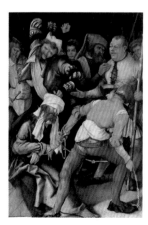

19
Goebbels giving a speech: illustration from
Heinrich Hoffmann, *Deutschland Erwacht*
(*Germany Awakes*), 1932

been surmounted by a depiction of the Crucifixion, epitomizing man's
capacity for barbaric cruelty towards his fellows, while the Eumenides
evoked in equally mythic terms the revenge that inevitably followed for
those responsible for committing the most heinous crimes. This was exactly
what was happening in the contemporary world, as the tide of war turned.
In 1943–4, the period of the work's creation, the German military machine
and people were being subjected to the same destructive violence and
violation that the Nazis had earlier inflicted upon others. Such wartime
resonances are further implicit in the expressive ambiguity of the triptych,
especially the right-hand panel, whose occupant seems at one and the
same time to encapsulate the excruciating pain of the victim and a snarling
aggression evoking some wild beast or Nazi orator.

[19]

► FOCUS (5) THE SCREAMING MOUTH, P.54

20
New Reich Chancellery, Berlin
Illustration from Albert Speer,
Neue Deutsche Baukunst, 1941

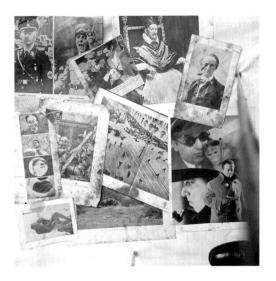

21
Montage of material from
Bacon's studio, 1950
Photograph by Sam Hunter

EMERGENCE

The triptych was the springboard for pictures over the next couple of years that similarly combined visual impact with more veiled references to photography of animals, religious imagery and the spectacle of Fascism. Bacon presented such powerful and controversial paintings in group exhibitions in London during 1945 and 1946, earning enough money from sales to spend a few years in the South of France, gambling in the casinos. In an ideal world he would have painted at this stage for personal satisfaction alone, but addictions to gambling and high living precluded financial security, so Bacon agreed to a one-man exhibition at the new, fashionable Hanover Gallery in London at the end of 1949. The show was a triumph, putting Bacon firmly on the artistic map.

A series of six heads revealed the transition in his work from expression- [32-3]
istic distortion – a process of psychological dissolution suggested by its
physical counterpart – to more naturalistic representation. The thick layers
of paint seen previously gave way to a new economy and manual delicacy,
with marks dragged over the texture of bare canvas (the rougher reverse side
in fact, which Bacon hereafter always preferred). Most extraordinarily, the
last head in the sequence was apparently assembled from two well-known [33]
but incongruous visual quotations, the body and purple robe from the great
portrait of Pope Innocent X by Diego Velázquez (1599–1660), and the head and [52]
screaming mouth from stills of the wounded nurse in Eisenstein's *Battleship* [50]
Potemkin. If emotionally charged imagery was the most visible hallmark of
Bacon's latest works, critics also noted inventiveness and seductive beauty
in his handling of paint.

▶ FOCUS ⑥ SERGEI EISENTEIN, P.56

Not all the work in the Hanover Gallery show was so horrifying. The ghostly *Study from the Human Body* from 1949 is a wonderfully simple and restrained painting. Both in its subject of a naked man passing through a curtain, and in its technique – the forms modelled in paint that barely caresses the canvas – the picture is among the most poignant expressions of human vulnerability in modern art. It provokes feelings of tenderness and compassion, which were all the more appropriate at a time when humanity seemed once again to be facing extreme and imminent threat, with the Soviet Union having matched America's acquisition of hydrogen bombs and the current crisis in Berlin, whose independence from East Germany was a potential catalyst for war.

In 1950 a young American critic, Sam Hunter, met Bacon, visited his studio and provided a vivid description of what he witnessed there. His enthusiastic article noted that the paintings 'are as artificial and immediately "modern" in their sensation as the loudspeaker, the newsreel, the scare headline'. He felt that Bacon was capturing 'contemporary post-war London, with its exacerbated nerves, its own distinct psychological atmosphere ... its sinister and claustrophobic overtones that deepen into horror'. Hunter noted the presence in Bacon's studio of 'tables littered with newspaper photographs and clippings' selected, it seemed, for their overtones of violence and their 'mysterious topical and psychological pertinence'. Invaluably he also reproduced shots of some of this material spread out on the studio floor.

The photographs that Bacon collected were the stimuli for the remarkable body of work that he produced and exhibited at the Hanover Gallery regularly between 1950 and 1954. He had now found the best format and scale for his vision, in tandem with an ideal technique for its realization that involved creating bare schematic settings from linear elements and flat chromatic planes, created either by paint that was often soaked in diluted form into the

22
Auguste Rodin (1840–1917)
The Crouching Woman, c.1881–2
Bronze
96 × 73 × 60 cm
(37 ¾ × 28 ¾ × 23 ¾ in)
Kunsthaus Zurich

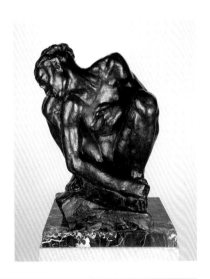

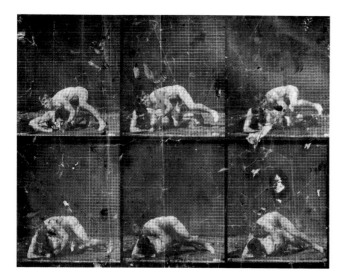

23
Eadweard Muybridge (1830–1904)
The Human Figure in Motion, 1887
Dublin City Gallery The Hugh Lane

canvas fabric or by leaving expanses of it bare. Against these backdrops Bacon placed figures (or occasionally animals) that are conjured into existence with improvised touches and smeared marks, sometimes worked with rags or using sand mixed into the paint, so that these elements float on top of the underlying darkness, moving in and out of focus. Other paintings of the naked human form, confined and acutely vulnerable, seem to interweave visual suggestions from drawings by Michelangelo, Muybridge's photographs and perhaps Auguste Rodin's sculpture. Bacon was particularly fond of his 1952 [22] *Study for Crouching Nude*, in which he edited out the individuality implicit in [35] facial features and projected an animalistic condition of humanity, an association emphasized by the squatting or crouching posture that recalls the body language of apes, reinforced by the cage-like setting.

Muybridge offered a particularly rich vein of inspiration at this time, allowing Bacon to choose the most suggestive images from photographic sequences documenting particular actions. In Bacon's hands, wrestling men [23] turned into two uncompromising and near bestial images of male intercourse. [37] A mangy and abject walking dog was placed within a stark geometric setting [36] that Bacon based on a Muybridge sequence and photographs of the vast Nazi [24] parade grounds constructed for the Nuremberg Rallies. Bacon seems to be [25] following the lead of those Old Masters who, in W. H. Auden's poem 'Musée des Beaux Arts' (1939), were never wrong about suffering:

> They never forgot
> That even the dreadful martyrdom must run its course
> Anyhow in a corner, some untidy spot
> Where the dogs go on with their doggy life ...

[26]

[53]

Photographs of the so-called 'Cathedral of Light', the massed searchlights that accompanied Hitler's ritualistic entrance at the Nuremberg Rallies and lit up the night sky, were evidently one source for the 1950 pope picture, *Study after Velázquez*, in which the screaming figure is veiled and partially dissolved by vertical linear marks. It is difficult to know whether Bacon intended any specific symbolic meaning in this image, but recent events clearly continued to preoccupy his imagination in a way that is virtually unique in the art of the period. His repeated experiments with papal portrayals, after Velázquez, stemmed from the subject's potential for dramatizing the immense gulf between the outer façade of power and control, and an underlying despair at the actual futility and brevity of human existence.

► FOCUS (7) THE POPE PICTURES, P.58

Bacon was wary when people tried to tie down the meaning of his pictures too neatly. A newspaper review by Neville Wallis of Bacon's 1950 Hanover Gallery show, which drew upon a conversation with the artist, reports:

> The artist has told me that his motives are purely aesthetic. That his obsession is with formal qualities, with forms at once concrete and dissolving, with the substance and texture of pigment, with the belief that every stroke of paint laid down ought to be a self-sufficient expression of the artist's idea. His reading, especially of Greek tragedy, has influenced his attitude ... but he would have us judge his paintings simply as works of art without seeking to read into them a symbolism never consciously premeditated.

24
Eadweard Muybridge
Mastiff, 1872–85
Dublin City Gallery
The Hugh Lane

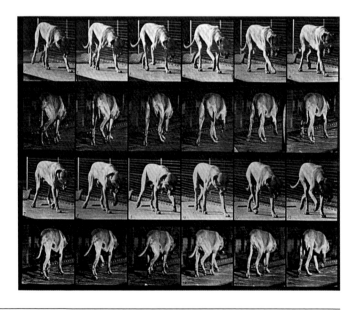

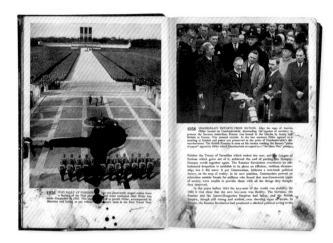

25
Photograph of parade ground for
Nuremberg Rally in a book found
in Bacon's studio

Years later Bacon made the same point more brutally: 'I'm just trying to make images as accurately off my nervous system as I can. I don't even know what half of them mean. I'm not trying to say anything.' Of course this has not stopped critics reading symbolic, philosophical or autobiographical messages into the pictures, as though these were what Bacon had really intended, whether he was conscious of the fact or not. The paintings certainly seem to invite such readings, and it would be absurd to maintain that they are purely about form and brushwork. Their ambiguity and open-endedness are precisely calibrated to provoke subjective interpretation in the viewer.

Around 1950 Bacon also began depicting particular individuals, either as portraits or recollections of more casual encounters. In 1951 he decided to make a portrait of his friend the painter Lucian Freud, but when the sitter [38]

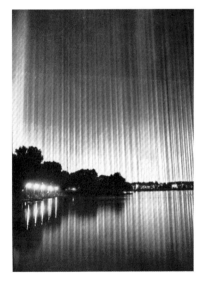

26
Albert Speer's 'Cathedral of Light'
at Nuremberg Rally, 1936

[27]

[39]

arrived at his studio he found the picture virtually complete, adapted from a photograph of Franz Kafka that Bacon had come across as the frontispiece to a book. Freud reciprocated the following year with the extraordinary, tiny image of his friend, baby-faced but lost in his own inner world. In 1953–4 Bacon created many depictions of seated, suited figures, set in murky interiors. Such works reflect a concern with intimacy, and the element of fantasy in personal assignations and relationships, that it is tempting to relate to Bacon's consuming affair with ex-pilot Peter Lacy. They may also reveal a desire to avoid being stereotyped as the painter of horror and despair, the artistic embodiment – like Giacometti in a French context – of a despairing 'existentialist' view of the individual's fundamental isolation. This general outlook had been rooted in wartime perceptions of human vulnerability, but had since hardened into cliché. It was in part because his work seemed so in tune with the mood of the moment that by his mid-forties Bacon was regarded by many as the most exciting current British painter, who made more established figures such as Ben Nicholson (1894–1982) or Graham Sutherland (1903–1980) look too polite and tasteful. Bacon's problem was how to maintain that reputation, and how to keep extending his artistic resources, as the general gloom of the post-war years began eventually to recede, and many people actually started to believe (to quote Prime Minister Harold Macmillan's 1957 phrase) that they had 'never had it so good'.

27
Lucian Freud (1922–2011)
Francis Bacon, 1952
Oil on metal
17.8 × 12.7 cm (7 × 5 in)
Tate, London
Stolen, 1988

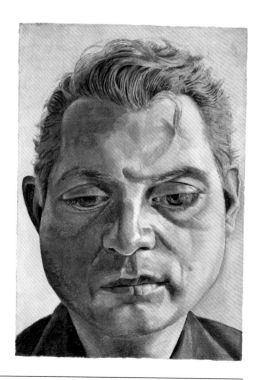

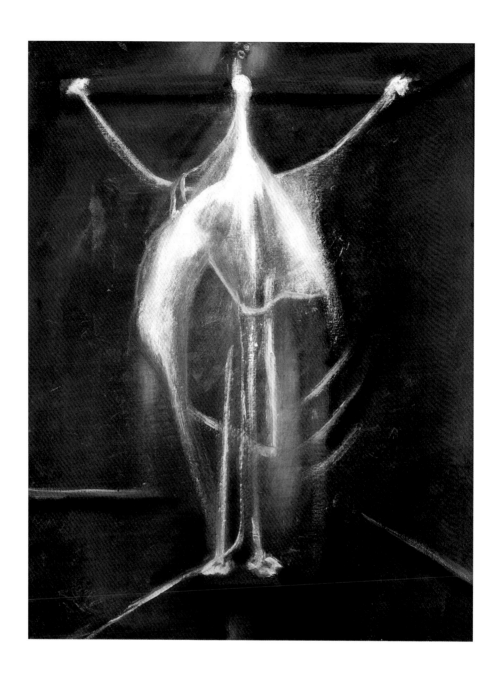

◄ 28
Rug, c.1929
Wool
215 × 125 cm
(84 ¾ × 49 ¼ in)
Tate, London

29
Crucifixion, 1933
Oil on canvas
60.5 × 47 cm (23 ¾ × 18 ½ in)
Murderme Collection, London

30
Figures in a Garden, c.1936
Oil on canvas
74 × 94 cm (29 ⅛ × 37 in)
Tate, London

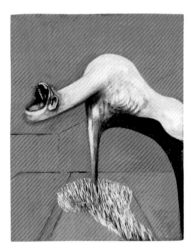

31
*Three Studies for Figures at the
Base of a Crucifixion, c.*1944
Oil and pastel on board
Triptych, each panel:
94 × 73.7 cm (37 × 29 in)
Tate, London

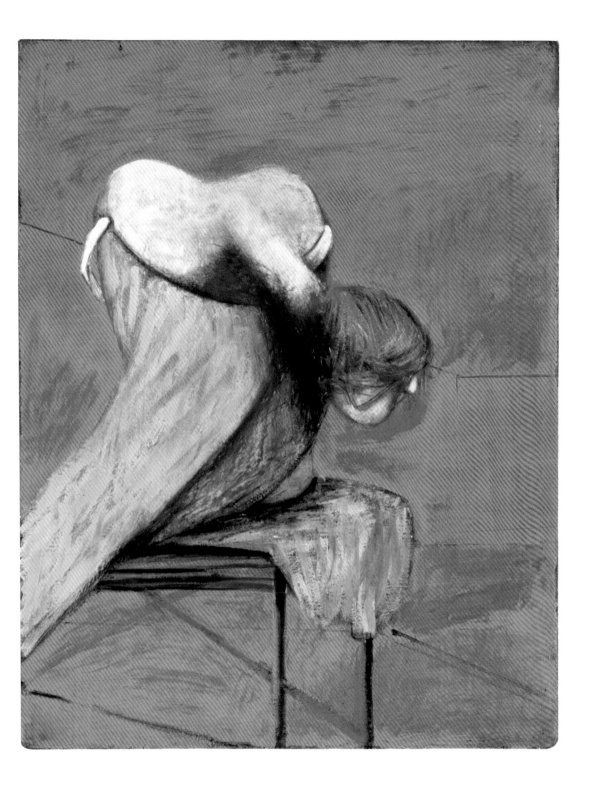

Left panel – *Three Studies for Figures at the Base of a Crucifixion*

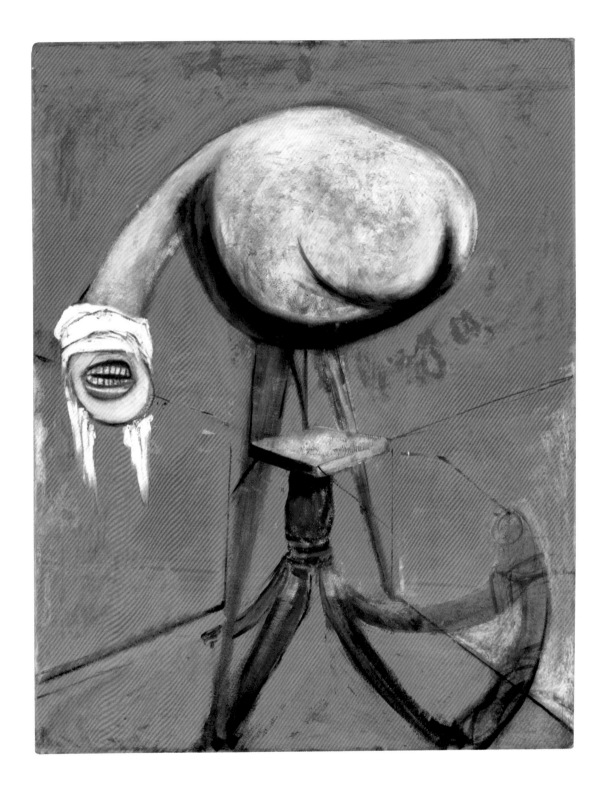

Central panel – *Three Studies for Figures at the Base of a Crucifixion*

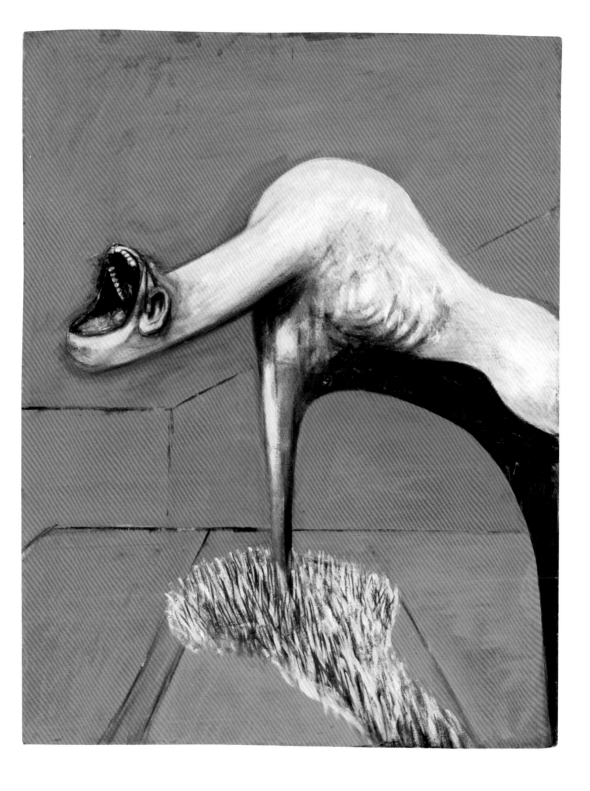

Right panel – *Three Studies for Figures at the Base of a Crucifixion*

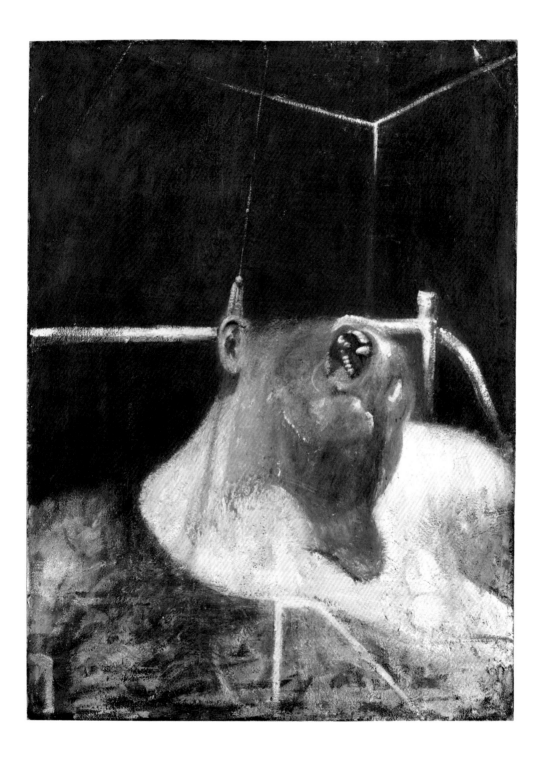

32
Head I, 1947-8
Oil and tempera on board
100.3 × 74.9 cm (39 ½ × 29 ½ in)
The Metropolitan Museum of Art,
New York

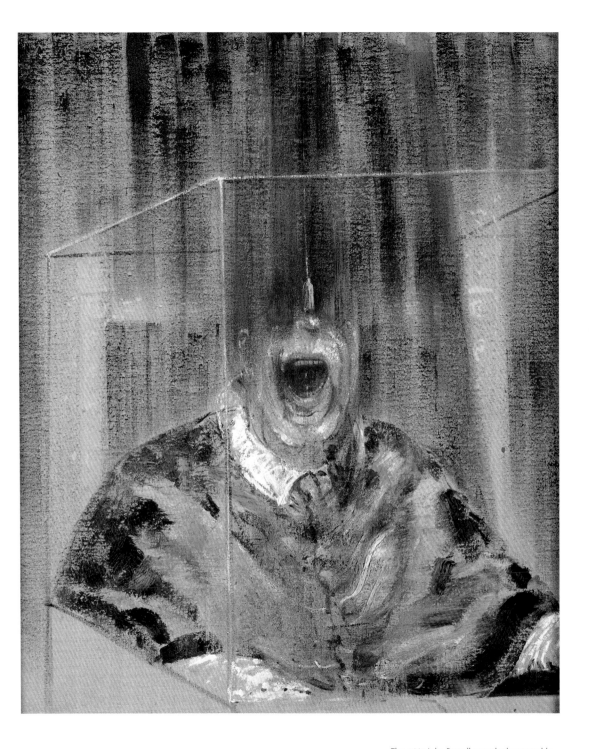

33
Head VI, 1949
Oil on canvas
93.2 × 76.5 cm (36 ½ × 30 in)
Arts Council Collection,
Southbank Centre, London

The critic John Russell remarked memorably of Bacon's *Heads*: 'What painting had never shown before is the disintegration of the social being which takes place when one is alone in a room ... We may feel at such times that the accepted hierarchy of our features is collapsing, and that we are by turns all teeth, all eye, all ear, all nose.'

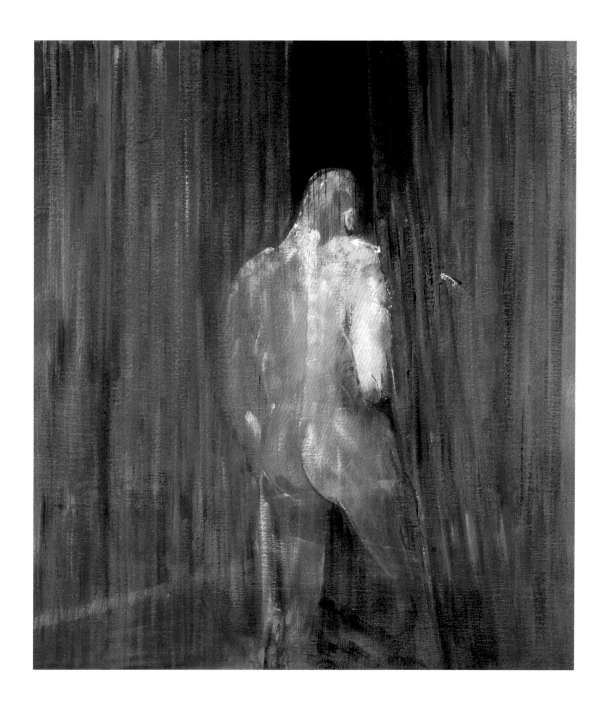

34
Study from the Human Body, 1949
Oil on canvas
147.5 × 131 cm (58 × 51 ½ in)
National Gallery of Victoria, Melbourne

35 ►
Study for Crouching Nude, 1952
Oil on canvas
198 × 137 cm (78 × 54 in)
The Detroit Institute of Arts

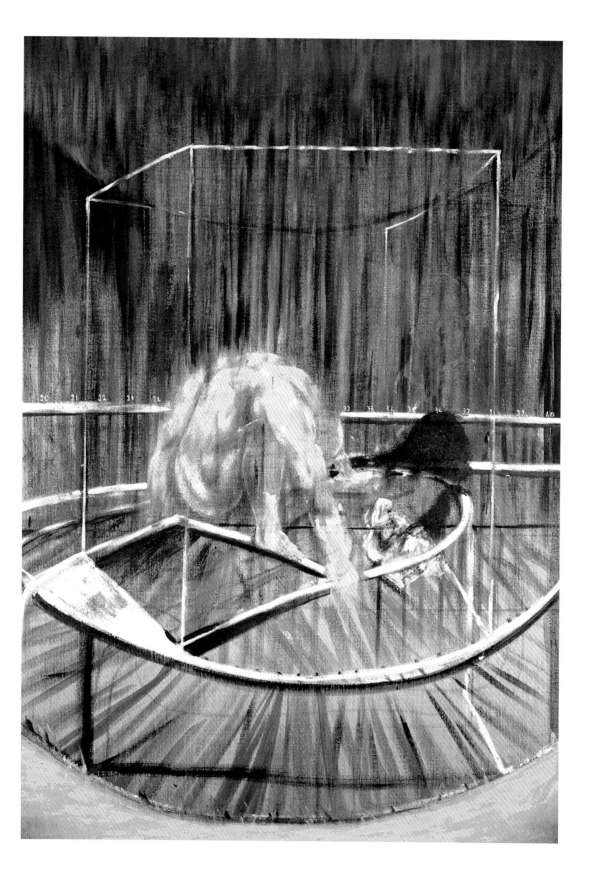

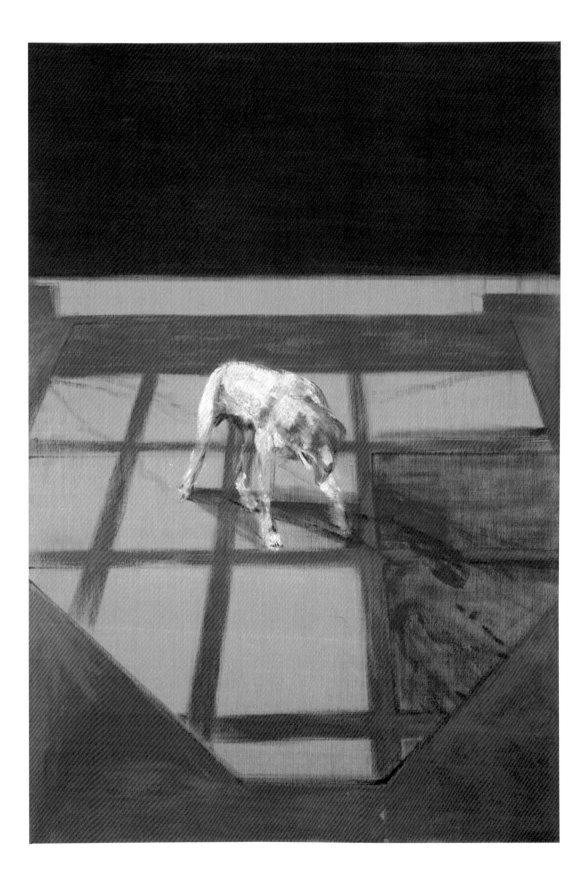

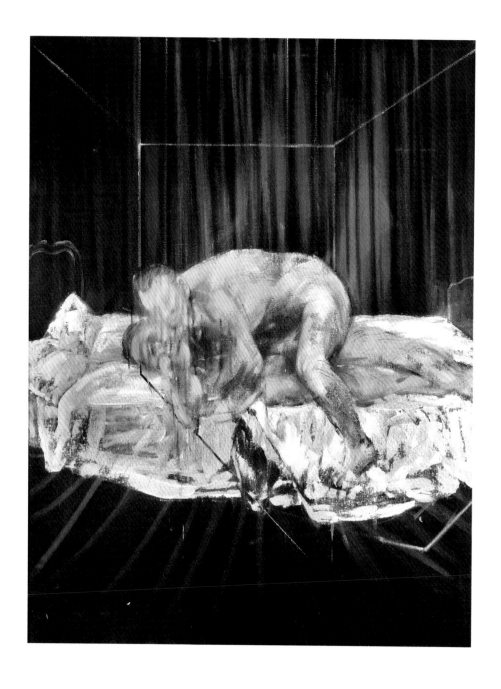

◄ 36
Dog, 1952
Oil on canvas
199 × 138 cm
(78 ¼ × 54 ¼ in)
Private collection

37
Two Figures, 1953
Oil on canvas
152.5 × 116.5 cm
(60 × 45 in)
Private collection

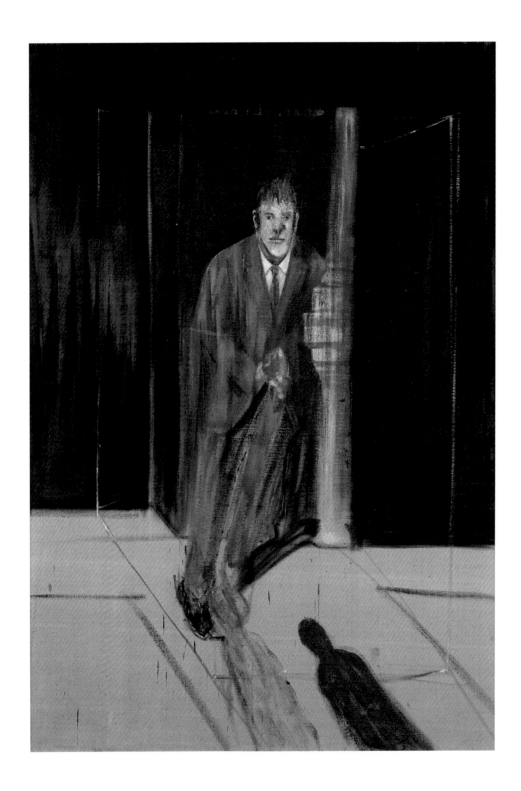

38
Portrait of Lucian Freud, 1951
Oil on canvas
198 × 137 cm (78 × 54 in)
Whitworth Art Gallery, Manchester

39
Man in Blue V, 1954
Oil on canvas
198 × 137 cm (78 × 54 in)
Kunstsammlung Nordrhein-Westfalen,
Düsseldorf

FOCUS ④

PAINTING, 1946

Painting [42] is one of Bacon's best-known canvases. In part this is because a London gallery acquired it in the year it was painted, 1946, and the painting was sold two years later to The Museum of Modern Art, New York. The picture therefore joined what for many years seemed a definitive collection of the most significant works in the history of modern art. Because Bacon combined paint and pastel, the surface is unstable and so the canvas itself cannot leave New York, but reproductions are ubiquitous.

Bacon often talked about the process of free improvisation that produced the final painting, beginning, he recalled, with the depiction of a bird in a field. If the spontaneity of the picture's making evoked the Surrealist idea of automatism, whereby the artist delved into his or her subconscious feelings and instincts by eliminating conscious control, the final image also extended the Surrealist method of juxtaposing utterly incongruous elements (figure, blinds, carcass, umbrella, flower) to suggest the irrational world of the dream [40]. The presence of meat also indicates Bacon's great admiration for the early work of the Jewish 'School of Paris' artist Chaïm Soutine [41], which featured many suspended carcasses of beef.

Ultimately, *Painting* goes well beyond any such inspirations. The sinister figure suggests a composite of the dictator figures, embodiments of the Nietzchean will to power, who had so

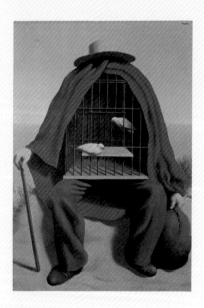

40
René Magritte (1898–1967)
The Therapist (Le Thérapeute), 1937
Oil on canvas
92 × 65 cm (36 ¼ × 25 ⅝ in)
Private collection

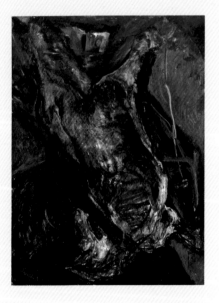

41
Chaïm Soutine (1893–1943)
Carcass of Beef, c.1925
Oil on canvas
156.2 × 122.6 cm (61 ½ × 48 ¼ in)
Albright-Knox Art Gallery, Buffalo

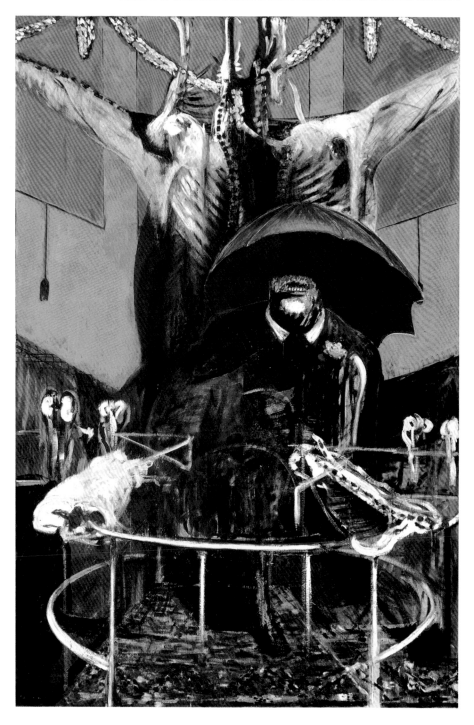

42
Painting, 1946
Oil and pastel on linen
198 × 132 cm (78 × 52 in)
The Museum of Modern Art, New York

maliciously presided over recent history. Hitler, Goebbels, Goering and Mussolini were commonly shown at the podium, screaming their message of hate into the microphones. One photograph of the Führer in front of the heraldic Nazi eagle [43] seems a key point of reference for Bacon's figure set against an animal carcass, which likewise evokes a scenario of religious ritual, as well as the Crucifixion of Christ. In *Painting*, the setting and its pink colouration also suggest the great mosaic hall that Speer had designed for Hitler's Chancellery building, which had been widely disseminated in colour photographs before the war [44]. Bacon's picture seems, then, to encapsulate an entire historical narrative of power corrupted, of the barbaric savagery that had always lurked beneath the Fascist

propaganda façade, and had resulted in mass torture and slaughter on a scale that was perhaps difficult even for him to grasp. However, Bacon had lived through the London Blitz and followed on a daily basis the unfolding of World War II in Europe, succeeded just as the conflict was finally concluding after six long years, by the revelations of the death camps in spring 1945, and by news several months later of the deployment of atomic bombs to bring closure to the war in East Asia. *Painting* was the culmination of a phase in which Bacon sought to distil artistically such overwhelming sensations and memories. It is a measure of how much the work meant to Bacon that he made a new version in 1971, which unlike the original could travel afield to exhibitions [45].

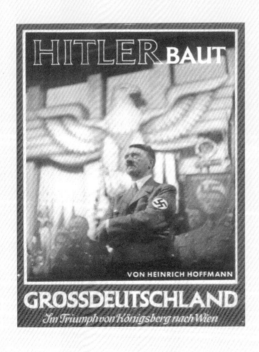

43
Dust jacket cover for Heinrich Hoffmann,
Hitler Baut Grossdeutschland, 1938

44
Albert Speer (1905–1981)
Mosaic Room, New Reich Chancellery,
Berlin, c.1939

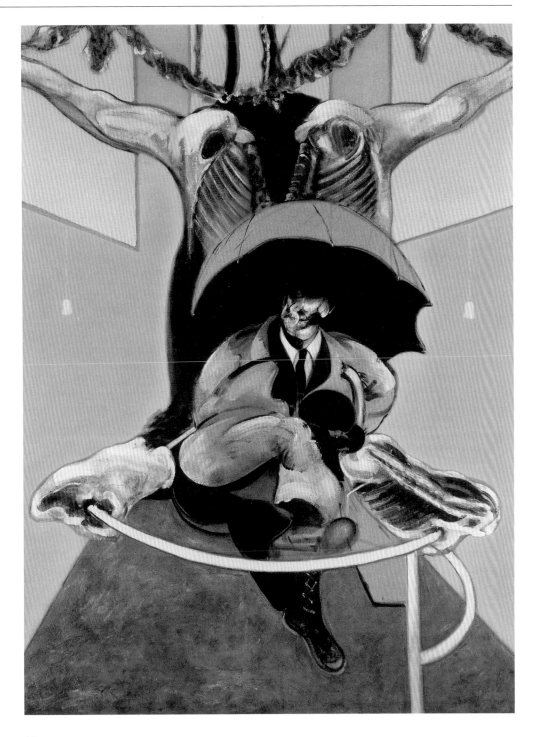

45
Second Version of 'Painting, 1946', 1971
Oil on canvas
198 × 147.5 cm (78 × 58 in)
Museum Ludwig, Cologne

FOCUS ⑤

THE SCREAMING MOUTH

For at least half of his working career, the wide open mouth was a recurrent element in Bacon's pictures [47]. Some commentators have felt that Bacon's lifelong asthmatic condition was a factor here, though this seems simplistic. The artist himself talked about wanting to paint the mouth as beautifully as the Impressionist Claude Monet (1840–1926) could portray a sunset. Deprived of the bodily movement and the sounds that accompany the same motif in everyday life or in films, an open mouth becomes highly ambiguous. It might variously evoke a cry or a scream, a yawn or a roar, a shout or even an unfettered outburst of laughter. It also has obvious sexual connotations. Confronted by relevant Bacons in this category, we reach most readily for the suggestion of a cry. The cry or scream is a frequent motif in the history of art, from the raving maenads of classical antiquity to Laocoön and his sons, and the legions of martyred saints or mothers of massacred innocents in Christian art. Nicolas Poussin painted a version of the latter theme [48], which Bacon encountered at the Musée Condé in Chantilly in the late 1920s and was in his view the greatest distillation of the human cry in art.

More modern variants on the open mouth, produced without reference to any communal symbolic narratives, require the viewer to do more interpreting. *The Scream* (1893) by Edvard Munch (1863–1944) or Picasso's numerous crying women have usually prompted critics to speculate about the biographical realities that lie behind the apparent torment or grief. With *Guernica* [15] and associated works by Picasso, private grief starts to assume a more collective resonance – his girlfriend Dora Maar turns into a symbol of Spain and its sorrows. The most compelling photographic equivalent is

Jacques-André Boiffard's *Mouth* [46], produced for a 1930 issue of the quasi-Surrealist magazine *Documents*. This radically visceral and blurred screaming mouth is isolated from the whole face and any context, just as it is in many of Bacon's pictures. The accompanying commentary in *Documents*, by the editor and dissident Surrealist author Georges Bataille (1897–1962), evokes the sense of primordial existential pain, shared by humans and other animals, which Bacon's art so powerfully conveys:

On important occasions human life is still bestially concentrated in the mouth: fury makes men grind their teeth, terror and atrocious suffering transform the mouth into the organ of tearing screams. On this subject it is easy to observe that the overwhelmed individual throws back his head while frenetically stretching his neck so that the mouth becomes, as far as possible, a prolongation of the spinal column, in other words, it assumes the position it normally occupies in the constitution of animals. As if explosive impulses were to spurt directly out of the body through the mouth, in the form of screams.

46
Jacques-André Boiffard
(1902–1961)
Mouth from
Documents, 1929

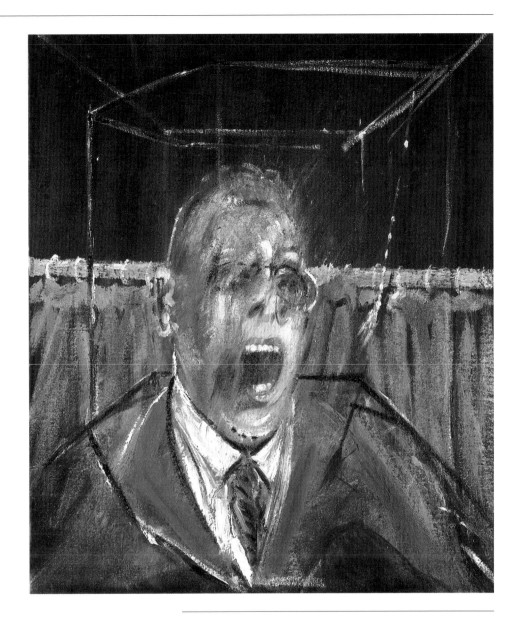

48
Nicolas Poussin
(1594–1665),
Massacre of the Innocents,
c.1625
147 × 171 cm
(58 × 67 ¼ in)
Musée Condé, Chantilly

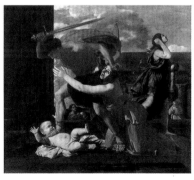

47
Study for a Portrait, 1952
Oil and sand on canvas
66 × 56 cm (26 × 22 in)
Tate, London

FOCUS ⑥

SERGEI EISENSTEIN

Bacon's quintessential motif of the scream derived in part from stills he encountered in publications about *Battleship Potemkin* [49, 50]. During his formative years the silent films of the innovative director Sergei Eisenstein, made in the Soviet Union in the early 1920s, were a touchstone for artists and intellectuals due to the potential convergence of artistic and political radicalism. Their 'remarkable' visual imagery 'strongly directed' Bacon towards becoming a painter. He was especially inspired by *Strike* and *Battleship Potemkin*, both of which incorporated references to butchery, as do several major pictures by Bacon, notably *Painting* [42]. In the climactic scene of *Strike*, shots of animals being slaughtered in the abattoir and rebellious workers being massacred are interwoven in one of Eisenstein's most dramatic montage sequences. In *Battleship Potemkin* it is the rotten meat, and the sailors' refusal to eat it, that becomes the catalyst for the mutiny, from which the entire tragic scenario unfolds. In each case, repellent flesh enhances the message that working men had been treated as no better than animals under the repressive Tsarist regime. There is no evidence that Bacon was on the political left, but he was profoundly influenced by the expressive intensity of Eisenstein's work.

After 1945, Eisenstein's most radical films were well known and widely appreciated, but it was also possible to view the director's recent historical productions, such as *Alexander Nevsky*, and engage with his theories, as expounded in *The Film Sense* (1943). One can readily imagine Bacon responding to Eisenstein's exposition of the montage technique, the abrupt cutting between contrasting shots, whose effectiveness resides in the fact that 'it includes in the creative process the emotions and mind of the spectator', who 'not only sees the represented elements of the finished work, but also experiences the dynamic process of the emergence and assembly of the image just as it was experienced by the author':

> It is precisely the *montage* principle, as distinguished from that of *representation*, which obliges spectators themselves to *create*, and the montage principle, by this means, achieves that great power of inner creative excitement in the *spectator* which distinguishes an emotionally exciting work from one that stops without going further than giving information or recording events.

Bacon's own pictures are organized according to a pictorial equivalent of montage, through their interplay of visual and thematic oppositions, while their layered and fragmented surfaces likewise invite identification with the creative process. They too are geared towards provoking the viewer's interpretation and emotional response, but with a significant difference inherent in their medium. Films, poems, novels and music are by nature art forms that are conceived as unfolding in time, however fragmentary their stylistic language, whereas paintings and photographs are single images, standing outside time or narrative, which spectators scan and make sense of in their own singular ways. The products of these media can be regarded as more ambiguous, more pregnant in their allusions and implications, and more open to subjective readings. Such a viewpoint seems to underlie Bacon's approach to photographs, including stills from the films of Eisenstein and others, which he recurrently mined in the making of his pictures, and to support his strong commitment to painting as an expressive instrument that operates in visceral, rather than narrative, terms.

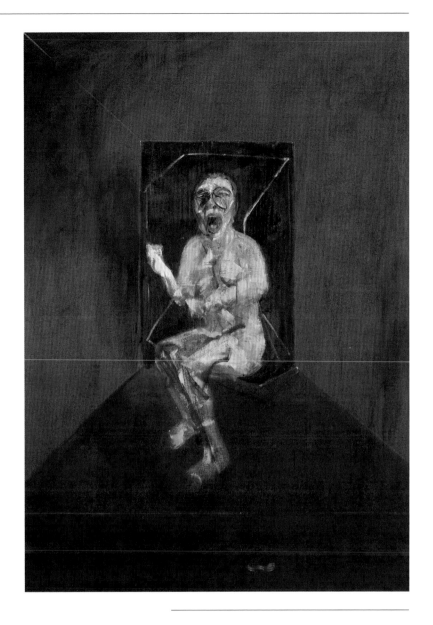

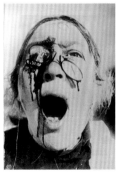

50
Still from Sergei Eisenstein's
Battleship Potemkin, 1925

49
*Study for the Nurse in the
Film 'Battleship Potemkin'*,
1957
Oil on canvas
198 × 142 (78 × 56 in)
Städel Museum,
Frankfurt am Main

FOCUS ⑦

THE POPE PICTURES

Bacon worked on his pope paintings, variations on Velázquez's magnificent portrait of *Pope Innocent X* [52], for over twenty years. He was already exploring the idea while in the South of France in late 1946. The first surviving version (*Head VI*) [33] dates from late 1949, and he finally stopped in the mid-1960s. Subsequently, Bacon announced that he thought the works 'silly' and wished he had never done them. He acquired endless reproductions of the Velázquez painting from books, but famously did not see the original when he visited Rome in late 1954.

Clearly Bacon was not just producing homages to a picture he loved. Artists have always made copies as creative exercises, and Bacon may have been particularly inspired by the example of Vincent van Gogh (1853–1890), who made many transformations of pictures that he especially admired by Eugène Delacroix (1798–1863), Jean-François Millet (1814–1875) and others. Bacon's popes depart even further from their source, often replacing the pontiff's head with the equally recognizable screaming face of the wounded nurse mown down by the soldiers' gunfire in the Odessa steps sequence of Eisenstein's film *Battleship Potemkin* [50]. The insertion subverts the encapsulation of power and self-assurance projected by Velázquez. The screaming mouth, isolated from other facial features and divorced from any narrative context, suggests existential agony. The pathos of human vulnerability and loss of faith or conviction are accentuated by the precisely rendered space frames in many Bacon images of popes, which make the figures register as 'enclosed in the wretched glass capsule of the human individual', to cite the evocative phrase used by the philosopher Friedrich Nietzsche in *The Birth of Tragedy* (1872), one of Bacon's favourite books.

The papal theme may have had a more contemporary resonance for Bacon, given that he embarked on his variations in 1946 immediately after the completion of *Painting* [42], with its dense references to Nazi iconography. He may have been attracted to the Velázquez picture as an iconic distillation of power, which made it such a vivid precursor to Fascist propaganda photography. In later works in the series, Bacon inserted references to photographs of the then pontiff, Pope Pius XII, a controversial figure who was thought by some to have appeased the Nazis. A photograph of Pius on his throne, being carried from St Peter's, appears in one of Sam Hunter's 1950 studio montages [21], and was clearly the basis for some of the subsequent pope pictures [54].

Bacon's obsessive reworking of the papal theme [51, 53] suggests that it may have possessed further significance and perhaps psychological charge for the artist in relation to his sexuality. It has been remarked that the Pope in official garb is in a sense the ultimate drag queen, or less literally that depictions of the Holy Father, known in Italy as 'il Papa', may encapsulate Bacon's traumatic feelings about his own father. The latter was a conventional, inflexible military man to whom the teenage Bacon had felt sexually attracted, as he recalled many years later, but who brutally admonished and rejected him when he discovered his son's homosexual inclinations. Such speculations about the possible 'subconscious' content of the pope pictures involve perhaps a rather crude application of the methods of Freudian psychoanalysis. Once again it is neither altogether possible nor helpful to pin Bacon down.

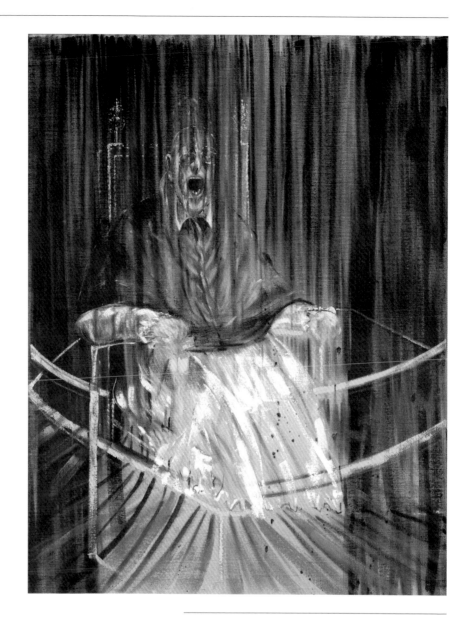

52
Diego Velázquez
(1599–1660)
Pope Innocent X, 1650
Oil on canvas
114 × 119 cm (45 × 47 in)
Doria Pamphilj Gallery, Rome

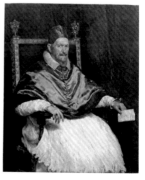

51
*Study after Velázquez's Portrait
of Pope Innocent X*, 1953
Oil on canvas
153 × 118 cm
(60 ¼ × 46 ½ in)
Des Moines Art Center

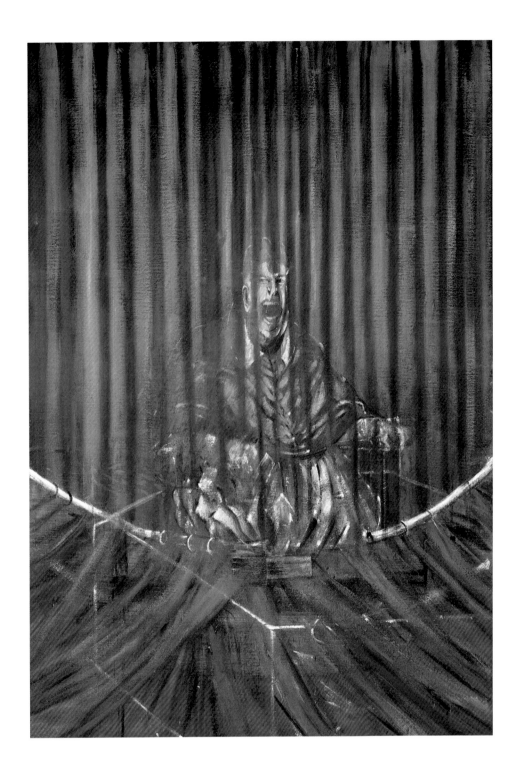

53
Study after Velázquez, 1950
Oil on canvas
198 × 137.2 cm (78 × 54 in)
Private collection

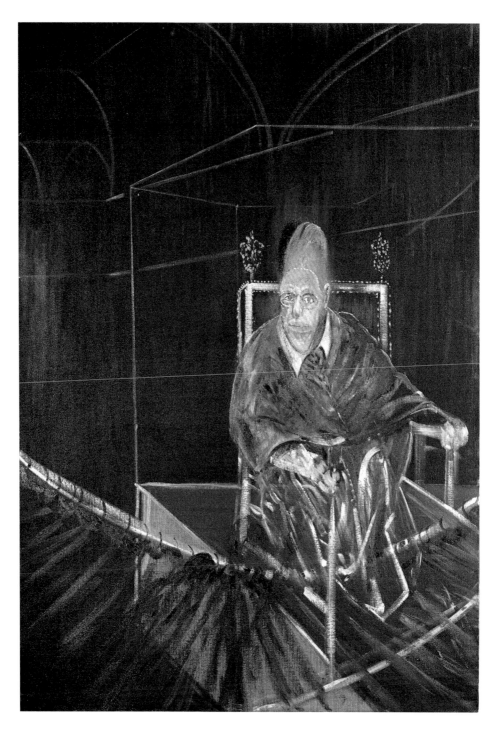

54
Pope I – Study after 'Pope Innocent X'
by Velázquez, 1951
Oil on canvas
198 × 137 cm (78 × 54 in)
Aberdeen Art Gallery and Museums

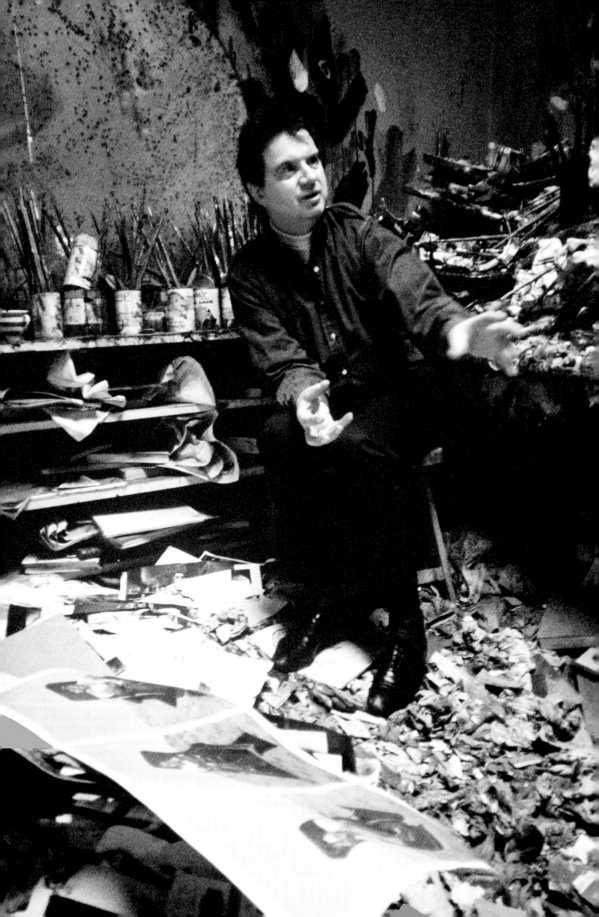

MID-CAREER, 1955–70

REINVENTION

The period from the mid-1950s to the early 1960s was one of uncertainty and even crisis for Bacon. His personal life was unsettled by the decline and eventual breakdown of his relationship with Peter Lacy, who died in 1962. Bacon spent long periods in Tangier, Morocco, an international mecca for bohemian homosexuals, and otherwise stayed for six years with friends in their London flat, without access to a proper studio. In 1959 he was even based for several months in picturesque St Ives in Cornwall, the main centre of British abstract art. This was at the suggestion of his new dealer, the highly commercial Marlborough Gallery. It undertook to set Bacon's finances and career on a sounder footing, after a prolonged period of financial disarray largely related to his compulsive gambling – this despite the fact that he was exhibiting regularly in America, Europe and London, and selling art to collectors and museums. Presumably the gallery's idea was that Bacon would be less exposed to temptation, and could settle down to producing the work that they needed to sell in order to recoup their guaranteed monthly outlay to the artist, a form of contractual relationship they had pioneered. At any rate, in 1961 Bacon felt able to move into a new flat with a studio, and, notwithstanding its relative modesty, he ended up staying there for the rest of his life. Marlborough mounted its first of many Bacon one-man shows in 1960, and helped to organize a series of major museum exhibitions, designed to boost the artist's reputation and prices. These began with a retrospective at the Tate Gallery in 1962, which consolidated Bacon's reputation and also marked the start of a period of artistic stability and sustained achievement.

[55, 57, 58]

[56]

Bacon's work since the mid-1950s had been characterized by an apparent loss of direction. The most obvious symptom of this was the exhibition of variations on a self-portrait by Van Gogh, a series that Bacon produced at great speed in 1957. The pictures indicate his identification with Van Gogh, the embodiment of the artist as social outsider, creating art out of his personal torments. Equally, the paintings reveal Bacon's immersion in the early work of Soutine from around 1920, with its radically free brushwork and dense pictorial organization. The paintings mark the reintroduction of bright colour after an extended use of dark tonalities. Yet they arguably lacked the power, tension and controlled spontaneity that had been such a distinctive feature of Bacon's previous work, especially when the Van Gogh works are measured

◄ Bacon in his studio, 1967.

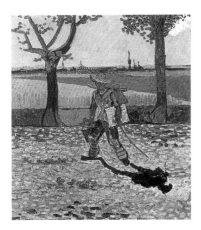

55
Vincent van Gogh (1853–1890)
The Painter on the Road to Tarascon, 1988
Oil on canvas
48 × 44 cm (19 × 17 ¼ in)
Destroyed during World War II

against the gestural 'Action Painting' of American artists like Willem de Kooning (1904–1997), which was now becoming known in Europe. In contrast to many younger British artists, Bacon was not impressed by Abstract Expressionism, which he regarded as merely decorative and all improvisation, without the necessary counterweight of order and discipline. One element in his reaction against current directions in art was a heightened interest in the great late nineteenth-century Realists such as Rodin and Degas, for whom Bacon expressed his admiration in annotations to several books, which surfaced after his death.

This has prompted critics to see affinities with Rodin in a series of awkward and flawed paintings from around 1960. Bacon focused on articulating figures (often naked) in various states of movement and relaxation, defining them sculpturally against simpler and increasingly colourful grounds. In moving [62, 63] away from such close dependence on photographic sources, Bacon exposed his somewhat insecure draughtsmanship. These particular pictures have also been connected with a substantial group of rather unsophisticated works depicting figures in interior settings that were made using pencil and paint on paper. Given Bacon's clear denials to Sylvester and others that he ever [61] made drawings, these sketches caused considerable consternation when they first appeared after his death, though Bacon was hardly the first major artist to have presented an oversimplified picture of how he worked. These drawings are usually dated to around 1960, because of the visual relationship with Bacon's concurrent paintings. Seeing an exhibition of Degas monotypes and drawings in London's Lefevre Gallery in the spring of 1958 may have prompted Bacon's specific figurative ideas as well as his move into experimenting with works on paper. Conversely, it may be that he used drawing to probe ideas throughout his career, and that Bacon was generally more successful than he was at this time (when he gave drawings to friends) in censoring the evidence of such activity from his studio sweepings.

MODERN TIMES

The 1960s was a period of immense accomplishment and productivity for Bacon. On the one hand, he revived his interest in religious imagery and the triptych format. On the other hand, he embarked on a sustained engagement with portraiture, announced by the naked sleeping figure of Peter Lacy and a head-and-shoulders depiction of Muriel Belcher, his drinking friend from the Colony Room, a private club he frequented in Soho. Bacon's new work was extensively exhibited, not only in museums at home and abroad but also in the London and New York galleries of his current dealer, the Marlborough Gallery. In his fifties, Bacon was now at the peak of his international reputation, even if he seemed old-fashioned to younger artists increasingly challenging the validity of figurative art and even painting as a medium.

► FOCUS ⑧ PORTRAITS: 'THE LIVING QUALITY', P.74

Bacon's work after 1960 exudes authority and artistic assurance. Familiar ambiguities coexist with a fresh clarity and bold simplicity. Bacon partly accomplished this by overpainting the background towards the end of the picture-making process with an expanse of flat unmodulated colour, employing what is usually described as acrylic but may often in fact have been ordinary household emulsion. The intense yellows, pinks and reds that he applied in this way contribute to the dramatic impact of the pictures. So too does Bacon's heightening of the effect of free mark-making, which he created by introducing highly visible and, one might say, ejaculatory blobs of white paint, which are sometimes worked into the surrounding paint texture in varying degrees. It is as though he has pitched both control and spontaneity, and the opposition of elegance and violence, at a new level of intensity.

56
Chaïm Soutine (1893–1943)
*Landscape at Céret, c.*1920–1
Oil on canvas
56 × 84 cm (22 × 33 in)
Tate, London

Although Bacon was supremely confident in his own singular artistic vision, at this point he was also taking on board, and competing with, the hard-edged clarity and bright artificial colours in works of contemporary American Pop art and abstraction, which were widely exhibited in London and rapidly seeping into fashion, interior decoration and the visual environment generally. Despite the generation gap, Bacon's art was a major reference point for younger figures such as R. B. Kitaj (1932–2007) and David Hockney (b. 1937). The former extended aspects of Bacon's style, and shared his concern to give artistic expression to some of the more sinister undercurrents in modern history. Hockney, for his part, admired the overt homosexuality of Bacon's persona and paintings, and the works with which he made his name in the early 1960s were steeped in Bacon's influence.

The pictorial idiom that characterized Bacon's art for the remainder of his career was definitively established in 1962. Above all, he made a major breakthrough with *Three Studies for a Crucifixion*. This seems to have been [78] deliberately created to form the culmination of his Tate retrospective of the same year, an event by which Bacon clearly set great store. He was asserting his distinctive artistic personality by reverting to the triptych format, Crucifixion reference and orange backdrops of the 1944 work, in which he [31] had found himself as an artist. The central blinds and butchered animals of the 1962 work also hearken back to *Painting*, another picture that evidently [42] gave him particular satisfaction. Now the scale, the piercing brightness of Bacon's palette, with reds and oranges played off against resonant blacks, and the cataclysmic violence of its enigmatic imagery, all proclaim Bacon's ambition and his newly won artistic maturity.

► FOCUS ⑨ CRUCIFIXIONS, P.96

Bacon's critic friend John Russell claimed around this time that 'the great subject' that the artist always had at the back of his mind was 'The History of Europe in My Lifetime'. An important letter that Bacon sent from Rome in late 1954 suggests how we might connect such an idea to his continuing fascination with photographs of Nazi Germany, as well as his appalled interest in more recent conflicts such as the Algerian War, which is documented by the illustrated magazines and newspaper colour supplements unearthed in his studio. A notion that he might compile some sort of publication prompted Bacon to describe 'a wonderful book of photographs' that he had acquired:

They are nearly all photographs which I have already got through collecting them over years, but I think a sort of life story which sees underneath the events of the last forty years, so that you would not know whether it was imagination or fact, is what I could do, as the photographs themselves of events could be distorted into a personal private meaning.

By bringing together photographs to convey a highly subjective record of what it had felt like to live through such a traumatic period, he continued, 'perhaps we could make something nearer to facts truer – and more exciting as though one was seeing the story of one's time for the first time'. The book never materialized, but Bacon's thinking can readily be transferred to his paintings, where photographs are indeed referenced and subjected to expressive distortion, so that public events seem interwoven with private feelings. In particular, the successive triptychs extending from those of 1944 and 1962 to the 1965 *Crucifixion*, where the most obvious new element is a figure with a Nazi swastika armband, suggest that we might align Bacon's general sense of the underlying historical current with the view expressed by social theorist Hannah Arendt in 1945: 'The problem of evil will be the fundamental question of post-war intellectual life in Europe – as death became the fundamental problem after the last war.' The only conceivable remedy was close personal relationships between individuals, whose importance to the artist is implicit in Bacon's portraiture.

[79]

57
Study for Portrait of Van Gogh III, 1957
Oil and sand on linen
198 × 142 cm (78 × 56 in)
Hirshhorn Museum and Sculpture Garden,
Smithsonian Institution, Washington, DC

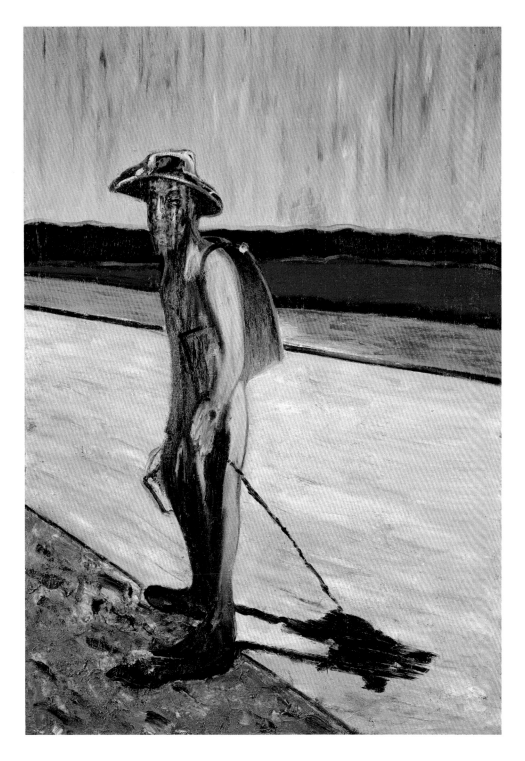

58
Study for Portrait of Van Gogh V, 1957
Oil and sand on canvas
198.7 × 137.5 cm (78 ⅛ × 54 ⅛ in)
Hirshhorn Museum and Sculpture Garden,
Smithsonian Institution, Washington, DC

59
Sleeping Figure, 1959
Oil on canvas
120 × 153 cm (47 ¼ × 60 ¼ in)
Private collection

Painted a decade after *Study from the Human Body* (see 34), this resumes its note of tender lyricism, tinged with erotic desire. Once again, feeling is conveyed not just by what is depicted but also by brushmarks that seem almost to caress the canvas. The subject here is Peter Lacy, with whom Bacon had a protracted but stormy relationship.

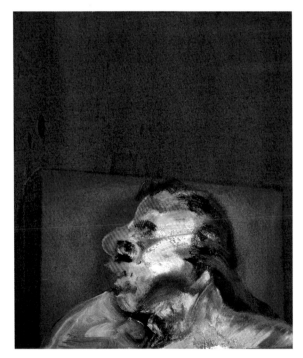

60
Miss Muriel Belcher, 1959
Oil on canvas
74 × 67.5 cm (29 × 26 ½ in)
Private collection

61
Bending Figure, No. 2, c.1957-61
Ballpoint pen and oil on paper
34 × 27 cm (13 ¼ × 10 ½ in)
Tate, London

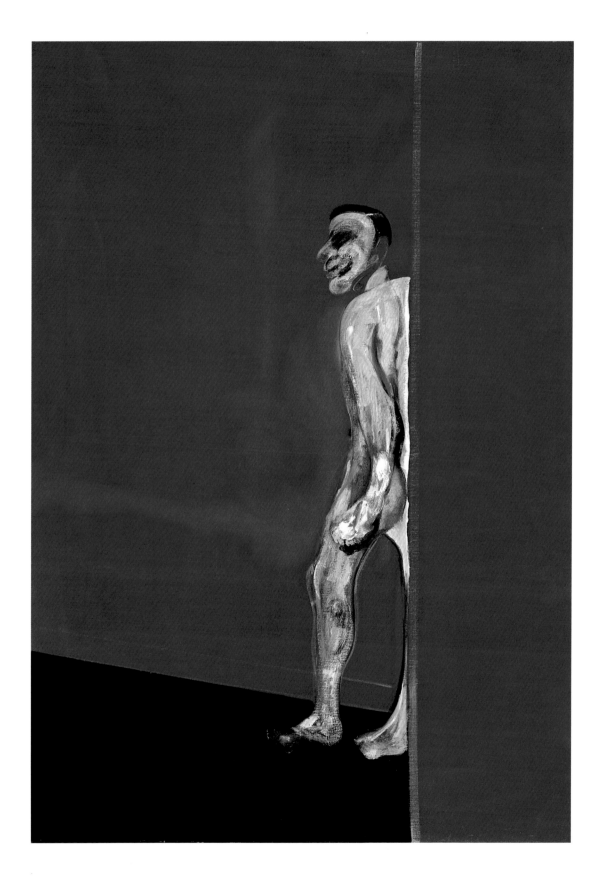

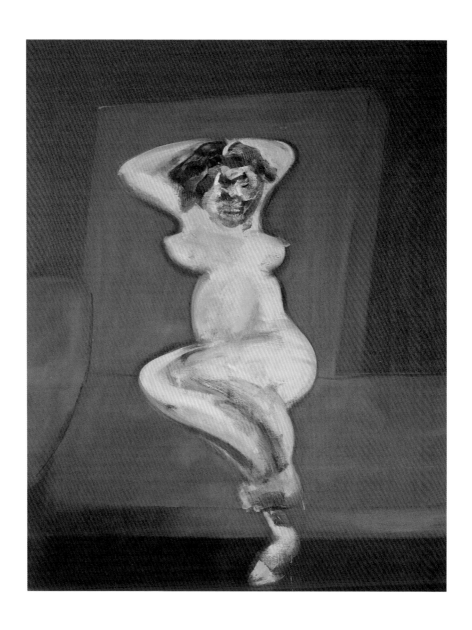

◄62
Walking Figure, c.1959–60
Oil on canvas
198 × 142 cm (78 × 56 in)
Dallas Museum of Art

63
Nude, 1960
Oil on canvas
152.4 × 119.7 cm (60 × 47 in)
Museum für Moderne Kunst,
Frankfurt am Main

FOCUS (8)

PORTRAITS: 'THE LIVING QUALITY'

The most convincing pictures from the 1960s are sensitive and intimate depictions of individuals in Bacon's life. Portraiture became a strong strand in his art. The genre was outmoded, and so ripe for reinvention in less descriptive and flattering terms, a possibility demonstrated by Picasso, as well as Old Masters such as Velázquez and Rembrandt whom Bacon revered for their psychological penetration. When portraying his close friends, Bacon painted for his own benefit rather than for that of the sitters. He produced many portraits of the artists Lucian Freud [74] and Isabel Rawsthorne [73], and another Soho *bon viveur*, Henrietta Moraes, who was often portrayed naked and rawly sexual [68, 70], with a nod surely to Sickert's portraits and remarkably frank nudes [64, 65]. A frequent subject was Bacon's new lover George Dyer [72], a good-looking, uneducated small-time criminal from the East End with whom Bacon began a relationship in 1963. Dyer features in Bacon's celebrations of the male body and its sexual appeal, as in the monumental triptychs of 1964 [69] and 1970 [75]. The latter especially can be seen as a masculine variant on the subject of the toilette, as well as the focus on the naked human back, which Degas had

explored so excitingly in works such as the large pastel on display in the National Gallery, London [66]. This Degas is known in fact to have been one of Bacon's favourite pictures. In other works Dyer is riding his bicycle [71] or sporting only underpants, which seem to cast him as ordinary to the point of slight absurdity. The light-hearted tone of such scenes may capture a phase of unusual serenity in Bacon's private life.

Bacon disliked executing portraits from life, however strong his personal rapport with the sitter. He stated in 1966:

> If I both know them and have photographs of them, I find it easier to work than actually having their presence in the room ... This may be just my own neurotic sense but I find it less inhibiting to work from them through memory and their photographs than actually having them seated there before me.

A few years earlier he had decided to commission another old friend from the Colony Room, the former *Vogue* photographer John Deakin, to produce numerous shots of his intended sitters in various

64
Walter Sickert
(1860–1942)
Sir Hugh Walpole, 1929
Oil on canvas
76.2 × 63.5 cm
(30 × 25 in)
Glasgow Museums and
Art Galleries

65
Walter Sickert
*L'affaire de Camden
Town*, 1909
Oil on canvas
61 × 41 cm
(24 × 16 in)
Private collection

indoor and outside locations, with Bacon directing their positions and gestures. Many large-scale Deakin prints survived in Bacon's studio, their torn, fragmentary and folded condition suggesting that they were a constant point of reference when he was painting portraits. They provided a concrete record of an individual's appearance and body language, which Bacon could then heighten through exaggeration, distortion, abstraction and the projection of visual and tactile memories. He could submit the prints to the same process previously performed on published photographs extracted from books or magazines. The resulting full-length portraits were sometimes presented in grand triptychs. The many small-scale paintings of heads and upper torsos were also sometimes grouped into triads consisting of a single sitter or of three different people, but establishing a consistent sequence of viewpoints of the faces depicted, as the spectator scans across the work. Bacon's account to Sylvester of what he was seeking in portraiture provides insight into his intentions:

The living quality is what you have to get. In painting a portrait the problem is to find a technique by which you can give over all the pulsations of a person. It's why portrait painting is so fascinating and difficult ... The sitter is someone of flesh and blood and what has to be caught is their emanation. I'm not talking in a spiritual way or anything like that – that is the last thing I believe in. But there are always emanations from people whoever they are, though some people's are stronger than others.

Of course, we cannot know what his friends were actually like, and whether Bacon was capturing something within them or projecting his own subjective perceptions. One certainly encounters a very particular psychological, physical presence in a work such as *Portrait of Isabel Rawsthorne Standing in a Street in Soho* [73]. Bacon had begun with a relatively banal Deakin print of his artist friend standing in front of a shop [67]. Through the dramatic transformations that he imposed on the figure and its setting, Bacon created a powerful and imposing presentation in the guise of some latter-day Medea or Clytemnestra type, or even a female matador, presiding over the arena that she commands.

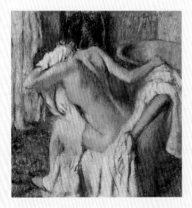

66
Edgar Degas
(1834–1917)
After the Bath, Woman Drying Herself, c.1890–5
Pastel on wove paper laid on millboard
103.5 × 98.5 cm
(40 ¾ × 38 ¾ in)
The National Gallery, London

67
John Deakin
(1912–1972)
Portrait of Isabel Rawsthorne Standing in a Street in Soho, c.1965
30.5 × 30.5 cm
(12 × 12 in)
Dublin City Gallery
The Hugh Lane

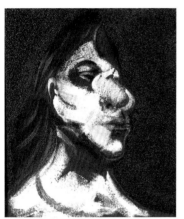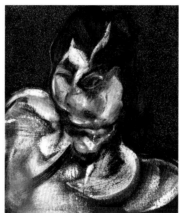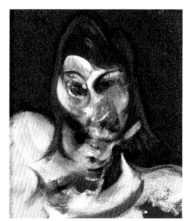

68
Three Studies for the Portrait of Henrietta Moraes, 1963
Oil on canvas
Triptych, each panel:
35.9 × 30.8 cm (14 ⅛ × 12 ⅛ in)
The Museum of Modern Art, New York

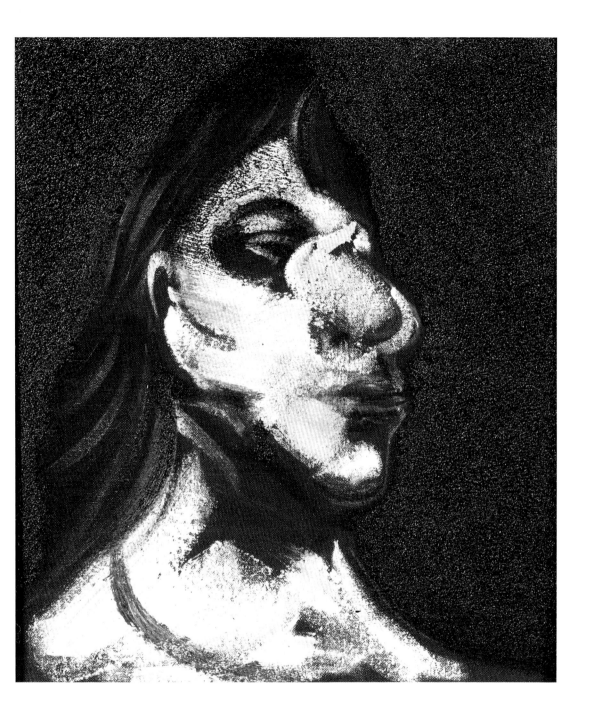

Left panel – *Three Studies for the Portrait of Henrietta Moraes*

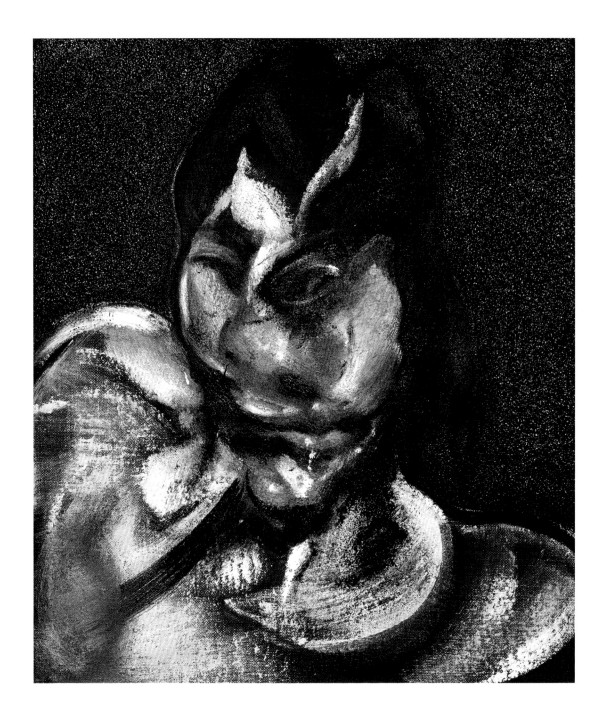

Central panel – *Three Studies for the Portrait of Henrietta Moraes*

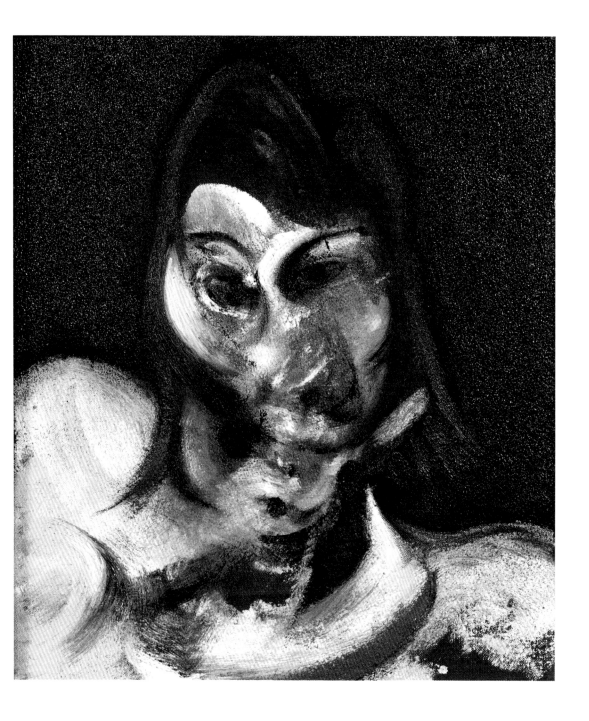

Right panel – *Three Studies for the Portrait of Henrietta Moraes*

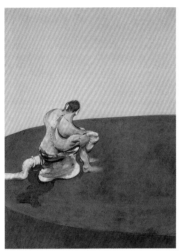
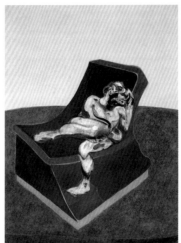
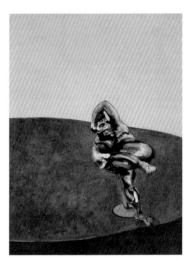

69
Three Figures in a Room, 1964
Oil on canvas
Triptych, each panel:
198 × 147.5 cm (78 × 58 in)
Centre Pompidou, Paris

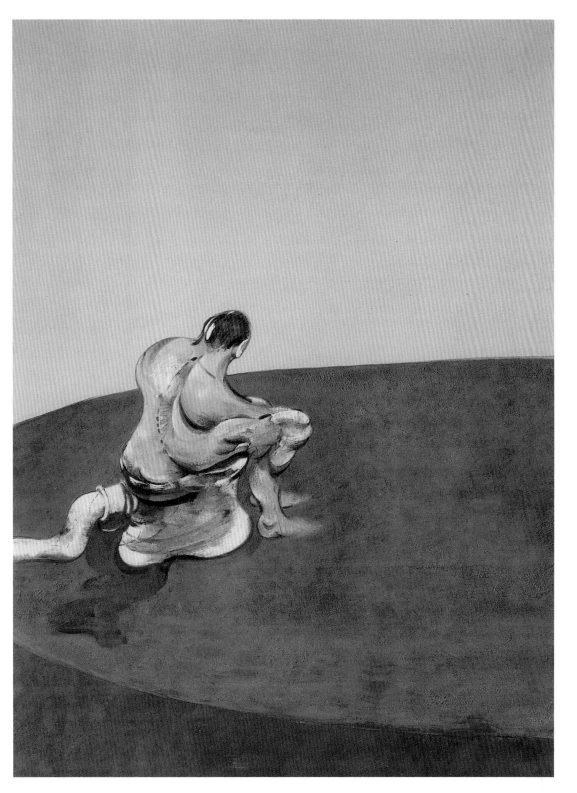

Left panel – *Three Figures in a Room*

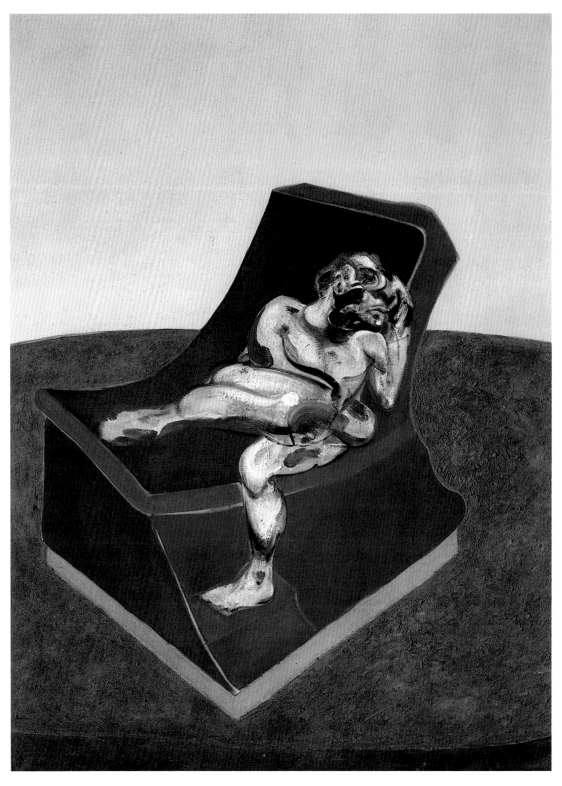

Central panel – *Three Figures in a Room*

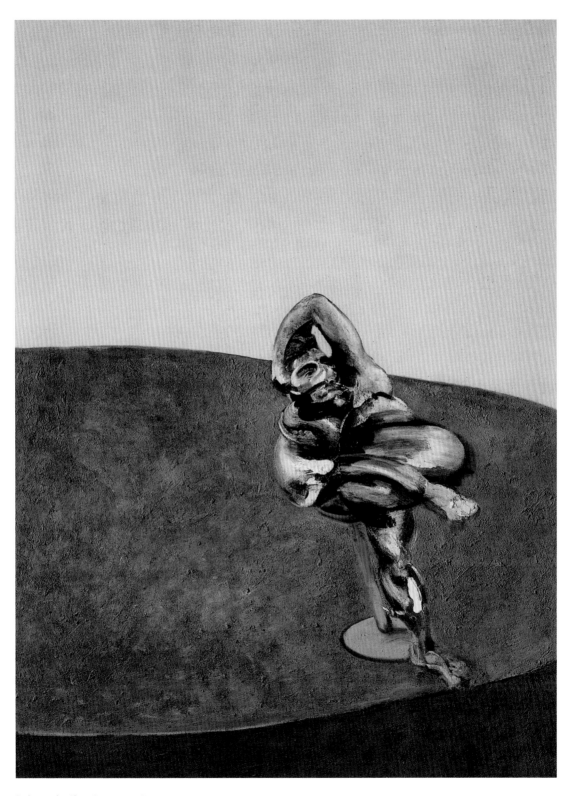

Right panel – *Three Figures in a Room*

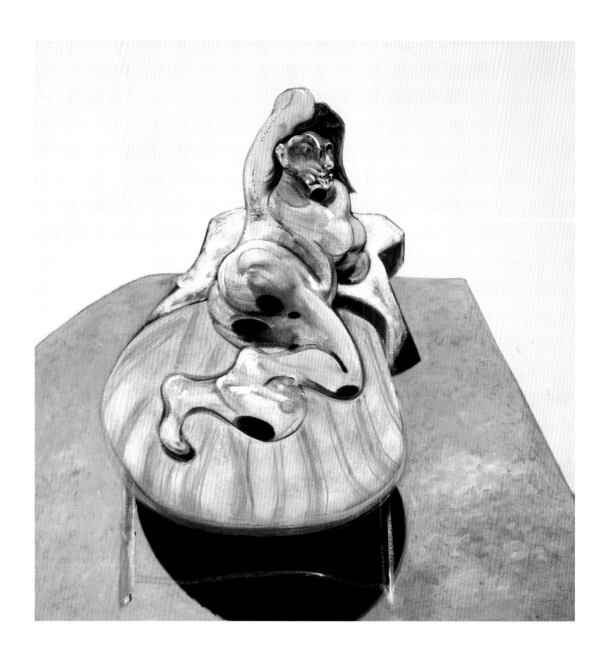

70
Henrietta Moraes, 1966
Oil on canvas
152 × 147 cm (60 × 58 in)
Private collection

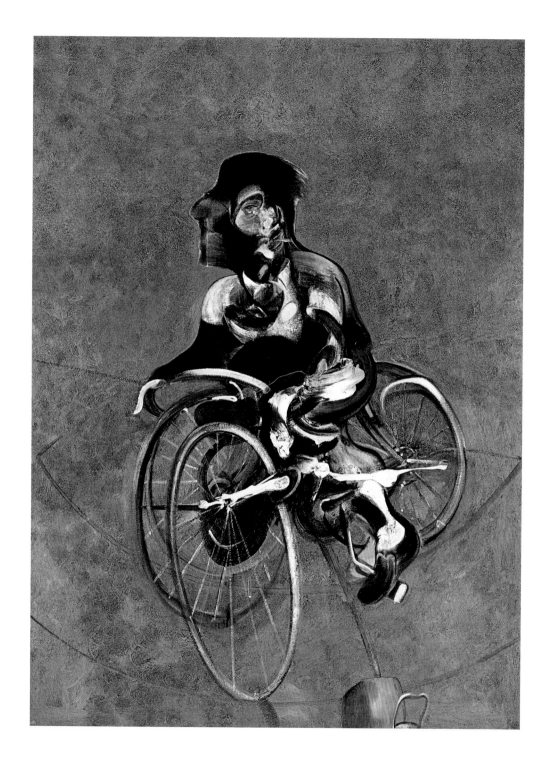

71
Portrait of George Dyer Riding a Bicycle, 1966
Oil and pastel on canvas
198 × 147.5 cm (78 × 58 in)
Fondation Beyeler, Basel

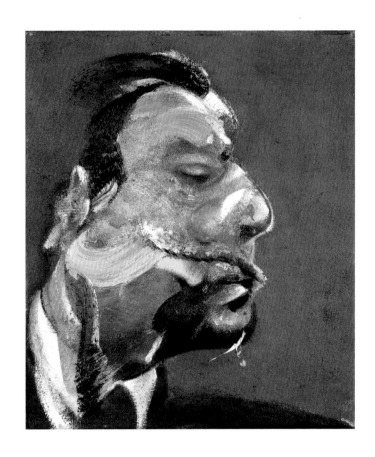

72
Study for Head of George Dyer, 1967
Oil on canvas
35.5 × 30.5 cm (14 × 12 in)
Private collection

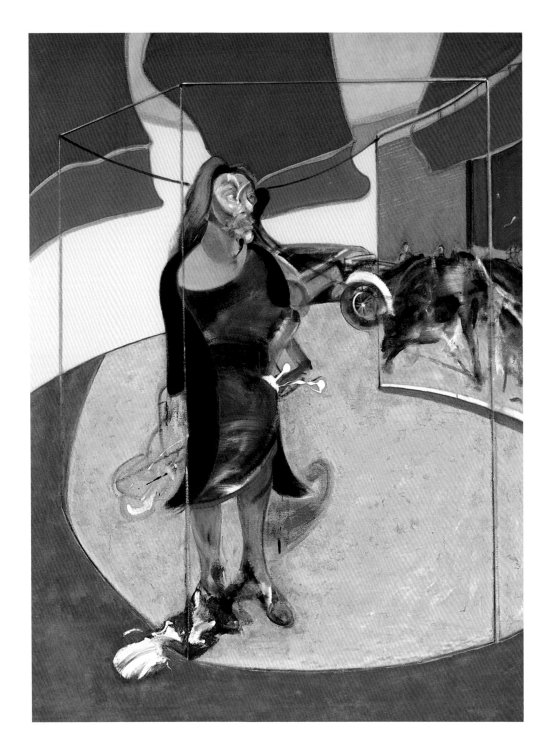

73
*Portrait of Isabel Rawsthorne Standing
in a Street in Soho*, 1967
Oil on canvas
198 × 147 cm (78 × 58 ⅞ in)
Staatliche Museen zu Berlin, Nationalgalerie

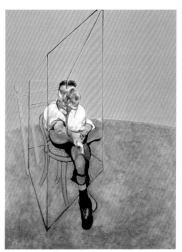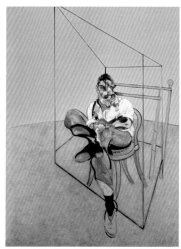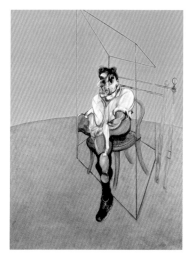

74
Three Studies of Lucian Freud, 1969
Oil on canvas
Triptych, each panel:
198 × 147.5cm (78 × 58 in)
Private collection

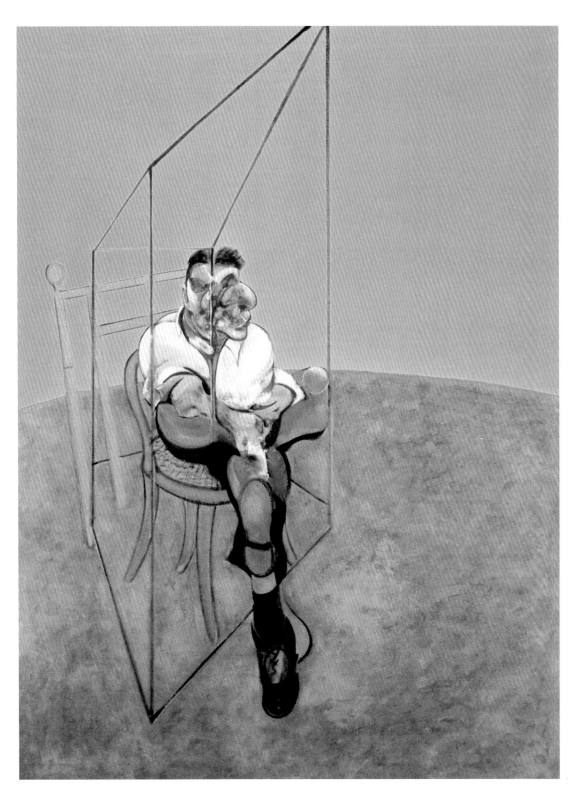

Left panel – *Three Studies of Lucian Freud*

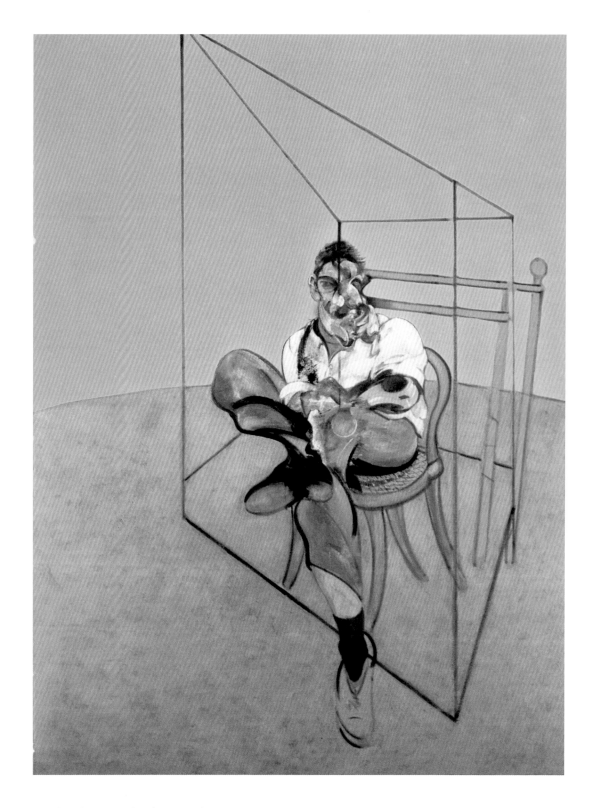

Central panel – *Three Studies of Lucian Freud*

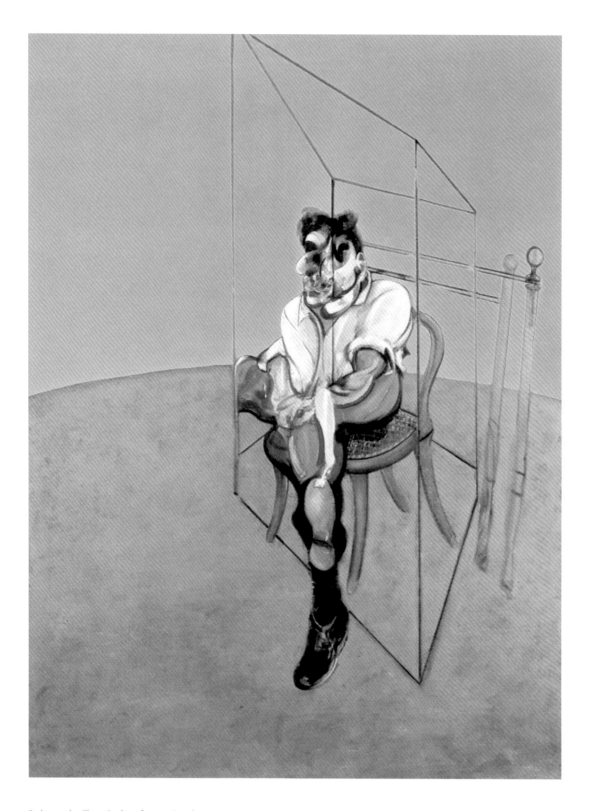

Right panel - *Three Studies of Lucian Freud*

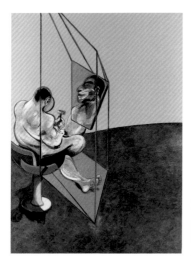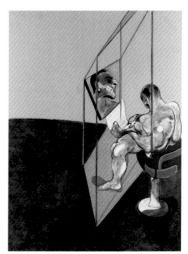

75
Three Studies of the Male Back, 1970
Triptych, each panel:
198 × 147.5 cm (78 × 58 in)
Kunsthaus Zurich

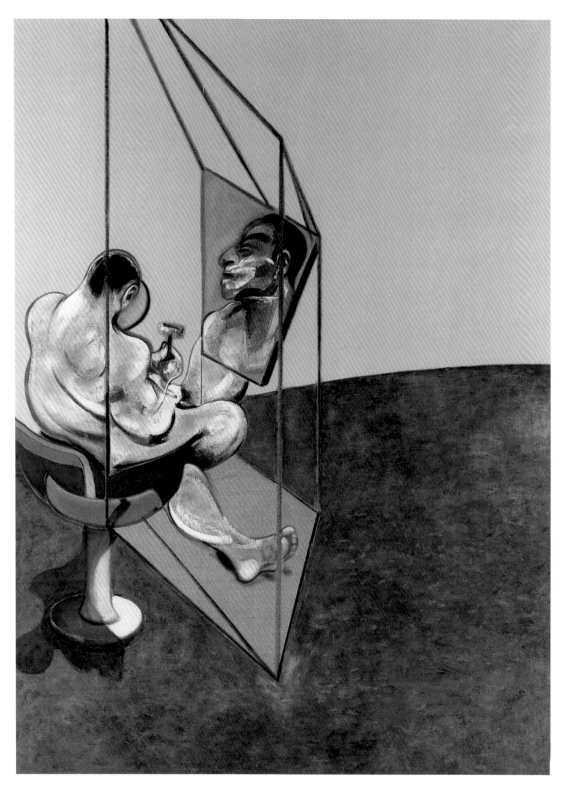

Left panel – *Three Studies of the Male Back*

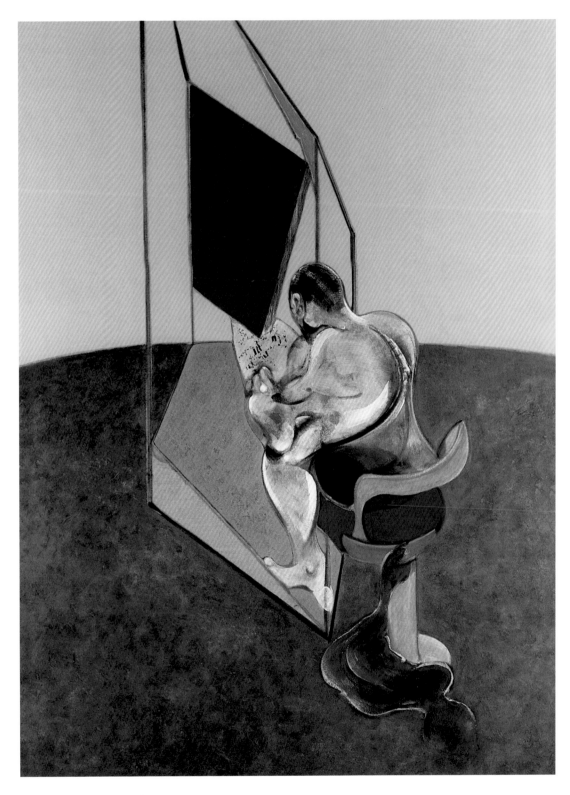

Central panel – *Three Studies of the Male Back*

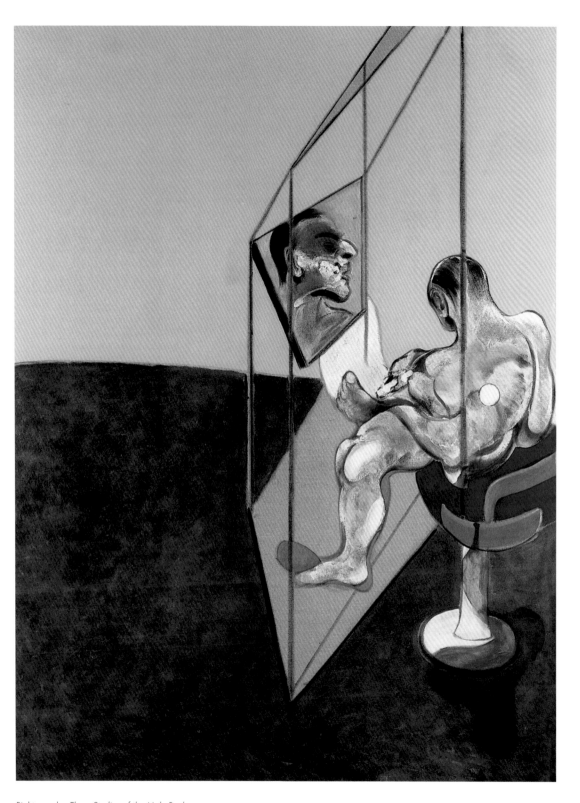

Right panel – *Three Studies of the Male Back*

Several modern artists have appropriated the subject of the Crucifixion for secular and metaphorical purposes, but none perhaps more inventively than Bacon [76]. He may initially have been inspired by Picasso's drawings [77] after Grünewald's *Isenheim Altarpiece* – itself a particularly unidealized and poignant treatment of the Crucifixion. Several early Bacons tackled the theme; a visitor recalled that his bedroom in the late 1930s contained 'a vast mural of a crucified arm ... with the nails in it, and just a hint of torso'. The Crucifixion featured in the titles of three important triptychs from 1944, 1962 [78] and 1965 [79], and in the splayed carcass of *Painting* [42].

Why was the militantly atheistic Bacon attracted to the Crucifixion? As with other artists, it presumably had strong connotations of man's capacity to inflict suffering upon his fellows, a suitable theme for an age dominated by world wars and massive, mechanized slaughter, which now extended beyond the military to civilian populations. Bacon's thinking was also steeped in that of the late nineteenth-century German philosopher Friedrich Nietzsche, who sought to reveal how far we are inescapably 'human, all too human' (the title of one of his books). Bacon identified with Nietzsche's concern to expose and dissect psychologically the immense gulf between the basic realities of our instinctive drives (such as power and sex) and the façade of 'civilized' behaviour, customs and religious beliefs that people tend to hide behind. What could more eloquently capture this innate hypocrisy than the centrality to the Christian tradition of the depiction of a virtually naked man, his hands and feet nailed to a Cross, whose excruciating and lingering death can scarcely be conceived? It may have struck Bacon that the promise of spiritual 'salvation' is projected onto a symbol that is rooted in the almost pornographic appeal of extreme physical violence. As a homosexual man with masochistic preferences, he may have been particularly alert to this quirk of the human psyche. His later pictures regularly interweave Crucifixion resonances with more explicit imagery of animal carcasses. Bacon professed that he simply found meat very beautiful, but again this may have epitomized humankind's unending capacity for self-deception. We can readily contemplate and consume lumps of flesh, conveniently overlooking where they come from, not to mention the realities of slaughter in the abattoir.

Bacon possibly had such human foibles in mind when he talked about the Crucifixion as 'a magnificent armature on which you can hang all types of feeling and sensation'. He intimated that the theme possessed a subjective significance for him, as a comment on the human condition: 'You might say that it's almost nearer to a self-portrait. You are working on all sorts of very private feelings about behaviour and the way life is.' On another occasion he made a comment about portraiture that distils his Nietzchean attitudes and ambitions for his work, including perhaps his preoccupation with the Crucifixion: 'We nearly always live through screens – a screened existence. And I sometimes think, when people say my work looks violent, that perhaps from time to time I have been able to clear away one or two of the veils or screens.'

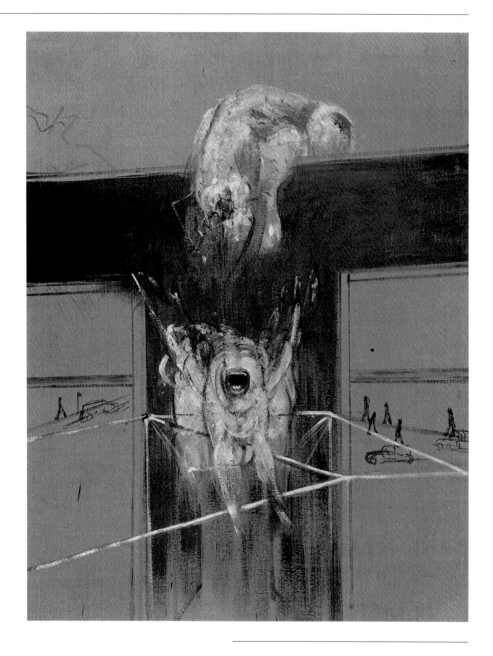

76
Fragment of a Crucifixion, 1950
Oil and cotton wool on canvas
139 × 108 cm (54 ¾ × 42 ½ in)
Van Abbemuseum, Eindhoven

77
Pablo Picasso (1881–1973)
Weeping Woman, 1937
Pencil and gouache on paper
29 × 23 cm
(11 ⅜ × 9 ⅛ in)
Museo Nacional Centro
de Arte Reina Sofia, Madrid

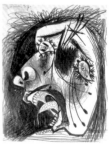

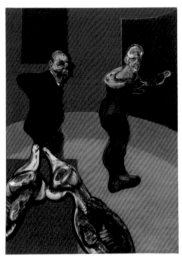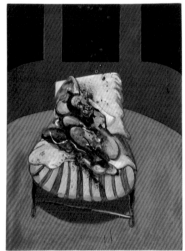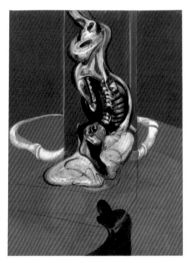

78
Three Studies for a Crucifixion, 1962
Oil and sand on canvas
Triptych, each panel:
198.2 × 144.8 cm (78 × 57 in)
Solomon R. Guggenheim Museum,
New York

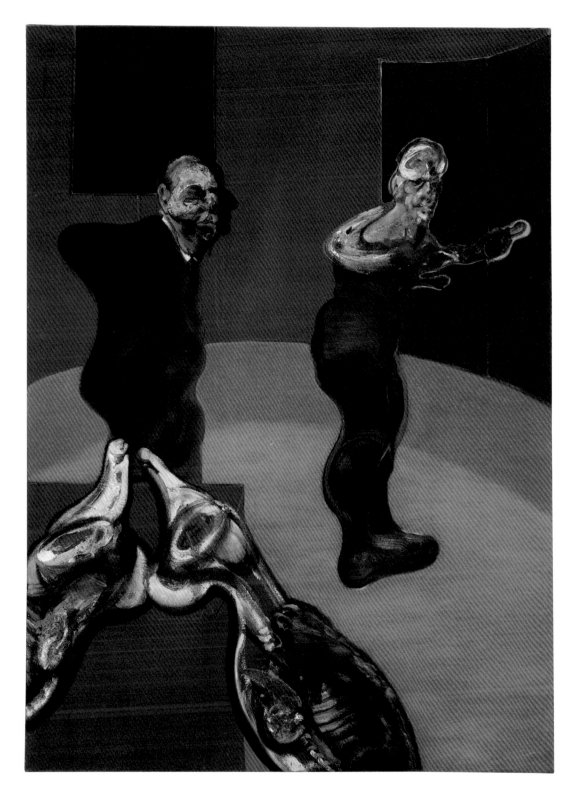

Left panel – *Three Studies for a Crucifixion*

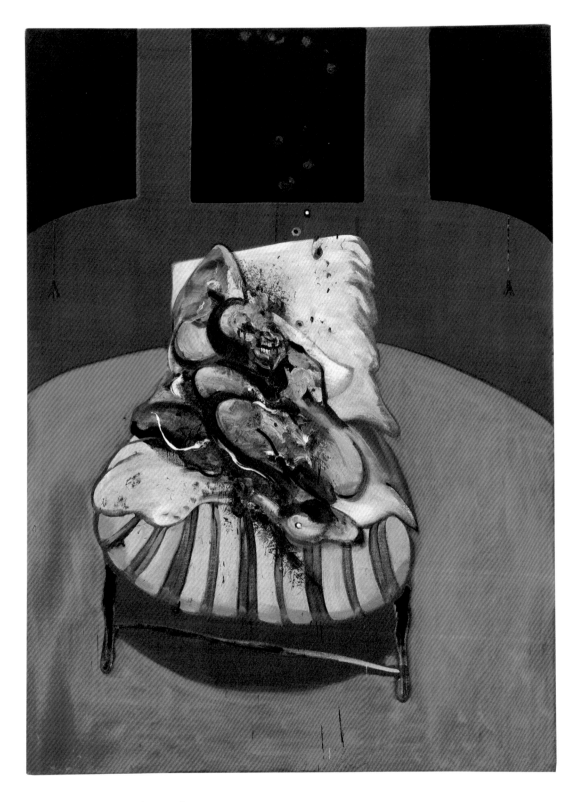

Central panel – *Three Studies for a Crucifixion*

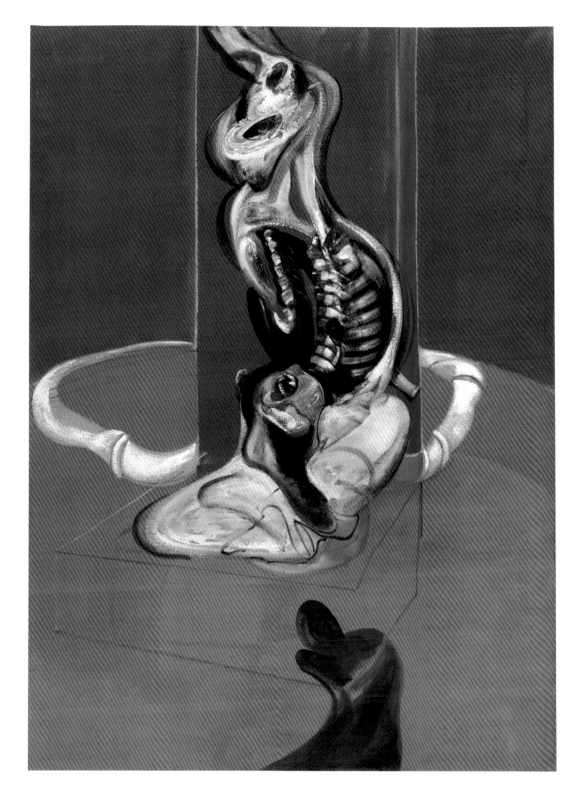

Right panel – *Three Studies for a Crucifixion*

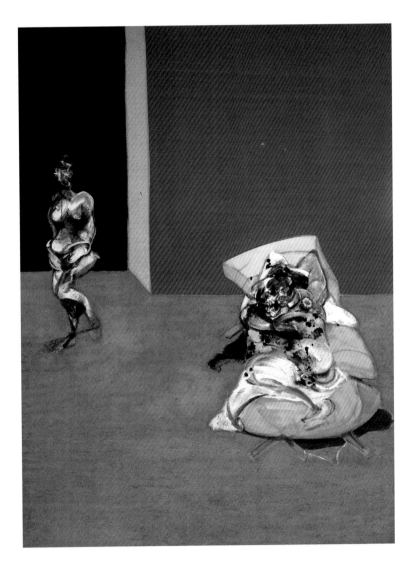

79
Crucifixion, 1965
Oil on canvas
Triptych, each panel:
198 × 147.5 cm (78 × 58 in)
Bayerische Staatsgemäldesammlungen,
Pinakothek der Moderne, Munich

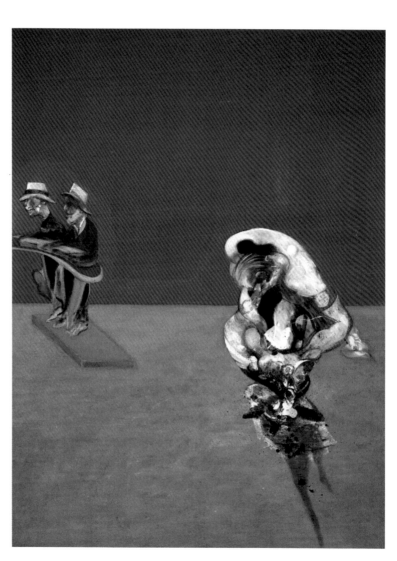

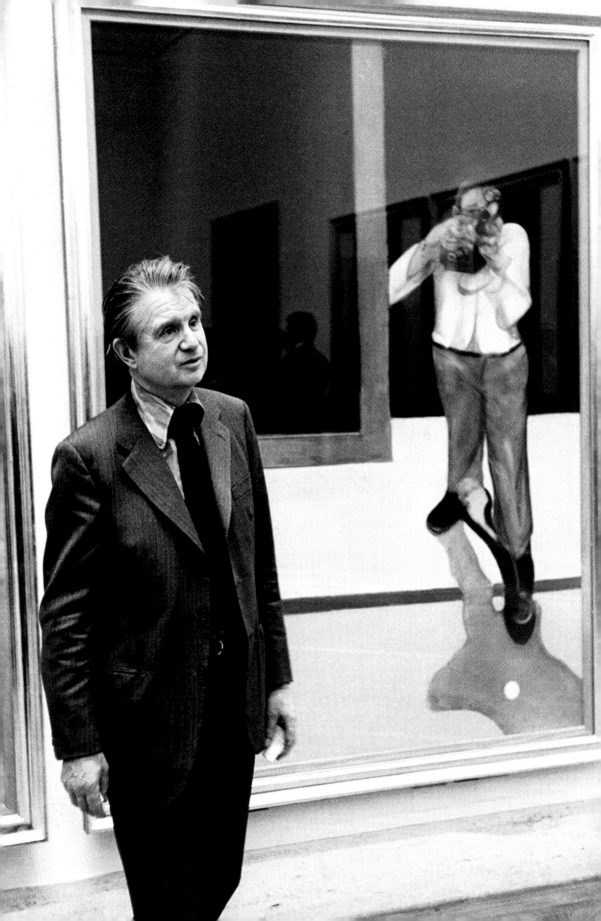

LATER YEARS, 1970–92

ELEGIES

Bacon's two principal modes in the 1960s, probing but sympathetic portraiture and tragic history painting, seem to converge in the early 1970s. The appalling occasion for this development in his art was George Dyer's suicide in a Paris hotel bedroom, when they were attending together the installation and grand opening of another Bacon retrospective in October 1971. Their relationship had been floundering for a good while, with Dyer utterly dependent on him but also completely out of his depth in Bacon's sophisticated and sometimes bitchy social world. Dyer resorted increasingly to drink and drugs, and had made previous attempts to take his own life, or at least to gain Bacon's attention. This time there was another big row, from which Bacon stalked out, and the following morning Dyer was found dead in their bathroom. Bacon somehow carried on as though nothing had happened, but the grief and doubtless guilt that he felt came out in a major sequence of triptychs which were conceived in some sense as memorials to Dyer.

[82] In the first work, painted quite soon after the event, the outer wings project Bacon's memories of Dyer as fallen boxer and as suited socialite. The elaborate central scene evokes the seedy urban melancholy of T. S. Eliot's early poems, especially a passage Bacon loved from *The Waste Land* that reflected upon the individual's ultimate isolation and mortality:

> I have heard the key
> Turn in the door once and turn once only
> We think of the key, each in his prison
> Thinking of the key, each confirms his prison.

[83] The second triptych reprises Deakin's photographs of Dyer, but with the life force draining out of his body in the form of puddles of flesh, while the central composition restates Bacon's archetypal theme of two bodies inter-penetrating in sexual union. The overall simplicity and muted colour range of the panels contribute an almost classical note of elegy, loosely recalling [80] Jacques-Louis David's great 1793 homage to the assassinated Jean-Paul Marat, a leading radical journalist and politician who was also the artist's [84] close friend. The most emotionally raw of the Dyer series is the final triptych, painted around twenty months after the event and vividly visualizing Dyer's final moments and death. Base human realities are heightened by the extreme simplification of the settings, and symbolic details such as the

◄ Bacon at his exhibition at The Metropolitan Museum of Art, New York, 1975.

80
Jacques-Louis David (1748–1825)
Death of Marat, 1793
Oil on canvas
162 × 128 cm (63 ¾ × 50 ⅜ in)
Royal Museums of Fine Arts of
Belgium, Brussels

arrows, the extinguished light bulb, and the shadow of what is presumably Fate, which encourages viewers to read the doorways as portals into the void, and the Rothko-esque maroons as more blood than hotel wallpaper. The emotional urgency embedded in the work is most eloquently conveyed by the relative crudity with which the paint is applied, as though the pressure of intense feeling made it impossible for Bacon to exercise his usual aesthetic finesse.

[81]

FINAL YEARS

Numerous large triptychs dominated Bacon's production during the last three decades of his career. The format conferred upon his work something of the grandeur and potency of traditional religious painting. It allowed him to combine a range of figures and scenes within a single work, while retaining separation and preventing the viewer from projecting a narrative, which a multi-figure composition might encourage. For Bacon, this would interfere with more visceral responses to the human presence portrayed. At the same time, the triptychs are often unified by very straightforward visual symmetries, and sometimes by continuous colour and spatial settings.

The content of such works was inspired on occasion by Bacon's immersion in literature, as in *Triptych – Inspired by T. S. Eliot's Poem 'Sweeney Agonistes'* (1967) and *Triptych Inspired by the Oresteia of Aeschylus*. These specific titles were almost certainly supplied by Bacon's Marlborough Gallery, picking up on hints that he had dropped in conversation about his points of departure. We know that the 1976 *Triptych* also relates to the pervasive violence and ritual sacrifice in the Oresteia. Unusually, the artist commented on the picture while he was in the midst of painting it, in a letter to his French writer friend Michel Leiris. It transpires that Bacon had been reading a recently published volume of Leiris's autobiography: 'I am currently working on quite a large triptych in which the accidents were based on the *Oresteia* of Aeschylus and

[87]

[85]

Heart of Darkness by [Joseph] Conrad, and now that I am at work I find that *Frele B* [a new book by Leiris] comes in all the time as well, all the time. So I do not know what accident will occur ...' Exploiting the accidental was a fundamental idea for Bacon, suggesting a freedom from conscious control. He often meant improvised brushwork, but here he seems to imply a free-flowing acceptance of shards of imagery triggered by what he had read. Indeed there is reason to think that he very often used the process of reading, and perhaps fixating on particular lines, as a way of psyching himself up to paint. This also included Shakespeare, especially the bleakly tragic tale of *Macbeth*. Bacon always insisted that it was not the elaboration of literary narrative that he was trying to reproduce, but the subjective effect and sensations that a powerful text provoked. In this respect, works of literature and photographs functioned comparably as stimuli to his creativity.

Between the mid-1940s and the mid-1970s Bacon produced an astonishingly rich body of work, consistent in its preoccupations while also relentlessly experimental in its search for an appropriately condensed and expressive artistic language. The more literary triptychs, painted, we should recall, on either side of Bacon's seventieth birthday, begin to raise the aesthetic difficulties that have been identified in his late work. Their elaborate mythic subject matter suggests that profound meanings are on offer to the suitably receptive spectator. However, the indirect relationship between the images and the original texts, combined with the unfamiliarity of such sources for all except erudite viewers, can leave the paintings looking somewhat portentous and bombastic. Above all, the subtlety of Bacon's handling of paint in his finest work of the 1950s and 1960s can appear sometimes to be coarsening into slickness and the formulaic. Earlier, he would not perhaps have committed himself to what he said to Sylvester in 1979: 'I think of myself as a maker of images. The image matters more than the beauty of the paint.'

81
Mark Rothko (1903–1970)
Black on Maroon, c.1958
Mixed media on canvas
229 × 207 cm (90 × 81 ½ in)
Tate, London

Conceivably, Bacon was starting to believe in the myth of his own genius, as nurtured by blockbuster retrospectives, lucrative sales and sycophantic admirers, and was now losing something of that self-critical edge which earlier had led him, if anything, to be over-zealous in rejecting and destroying works that failed to satisfy the artist completely. In his final decade a certain solipsism, as well as an eye to his artistic legacy, are apparent in the recurrent impulse to rework on a larger scale his old canonical themes such as the 1944 [90, 31] triptych, *Painting*, and the 1949 naked walking male seen from the back. The [42, 34] big portraits of Bacon's main companion in his later years, John Edwards, look like uninspired variations on his Deakin-derived pictures of George Dyer from fifteen to twenty years earlier, even down to the underpants. Photographs of his studio show Bacon surrounded by reproductions of his own work, and he acknowledged that these were a major point of departure for new pictures.

▶ FOCUS (10) BACON'S STUDIO, P.140

Of course many gifted and important artists, especially in the modern period, have eventually fallen away from the very highest levels of achievement. One might think of such diverse figures as Picasso and Jasper Johns (b. 1930) and have tended to repeat themselves in the absence of compelling new ideas (Warhol is a case in point). That Bacon to some degree fits this stereotype of decline was the widespread view of many observers during his lifetime, and it was a commonly expressed reaction among the critics who reviewed his 2008–9 centenary retrospectives. Their mistake was to allow that reasonable reservation to distract them from the originality and sheer painterly verve of Bacon's art over a period of several decades.

It should also be noted that Bacon produced truly remarkable pictures during the years immediately preceding his death in 1992, at the age of eighty-two. The high points include some of the small-scale portraits of sitters such as Edwards, the wildlife photographer and his new friend Peter Beard, and [89] especially the growing body of work in which Bacon scrutinized his own very distinctive facial features. The artist claimed that he felt compelled to resort to self-portraiture because all his old friends were dying off. Except for Dyer this [86] was not really true. One is bound to connect such works to the self-absorption of old age and, given their persistent air of melancholy, with Bacon's increasing awareness of his own mortality. Generally, it remains remarkable how the different individuals in the portraits, including himself, seem to project their own singular presence. There are, for example, considerable similarities of technique and artistic language between the 1976 and 1987 portraits of Michel Leiris and John Edwards, but also an enormous gulf in the characterization of [88, 89] the two men – an aged, sophisticated Parisian intellectual and a youthful working-class East Ender. Bacon conveyed the inwardness of the one and the physicality of the other through subtle adjustments within his portrait idiom.

[91]

[92]

Surprisingly, two of the most compelling larger pictures from Bacon's late period eliminate the figure almost entirely, which enabled him perhaps to sidestep the danger of repetition. *Jet of Water* can be seen as the culmination of his long-standing preoccupations with the spontaneous accidental mark, and with fixing movement and the transient moment, as though painting might even surpass the instantaneity of the photograph through its combination of momentary image and physical gesture. One might even read the picture as a metaphorical celebration of the life force, the primordial energy represented by the living self. *Blood on Pavement*, on the other hand, is altogether darker. It possesses the simplicity, frontality and grisaille palette of a late Rothko abstraction, interwoven with subject matter that in its understated manner distils Bacon's awareness that violent death is an utterly commonplace feature of everyday life. The respective affirmation and pathos of these two late pictures encapsulate Bacon's 'exhilarated despair', the imaginative terrain that so much of his work occupies.

82
Triptych – In Memory of George Dyer, 1971
Oil on canvas
Triptych, each panel:
198 × 147.5 cm (78 × 58 in)
Fondation Beyeler, Basel

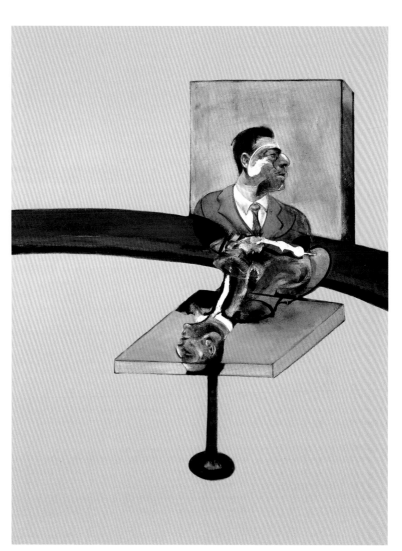

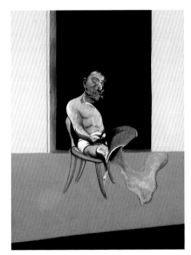

83
Triptych – August 1972, 1972
Oil on canvas
Triptych, each panel:
198 × 147.5 cm (78 × 58 in)
Tate, London

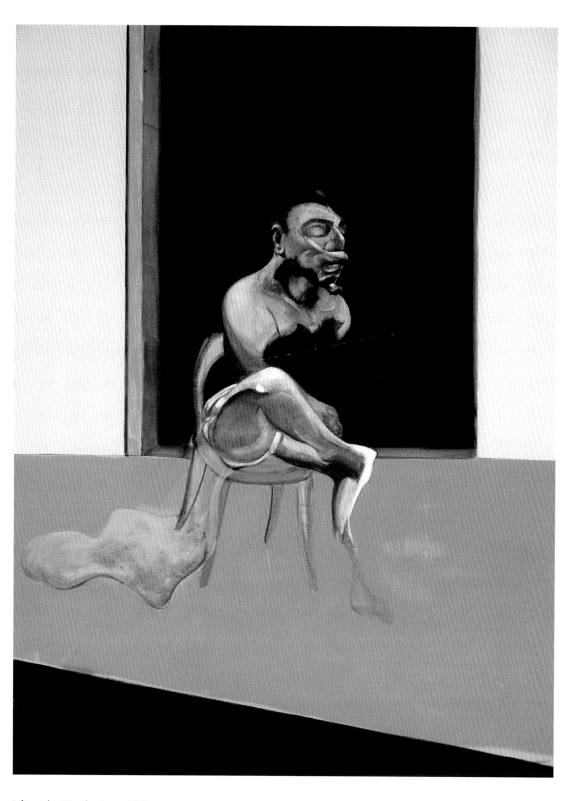

Left panel – *Triptych – August 1972*

Central panel - *Triptych – August 1972*

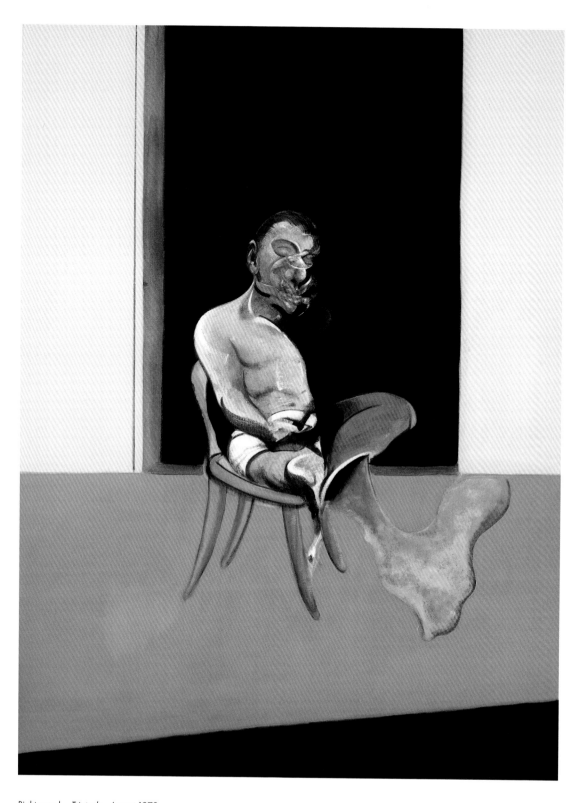

Right panel – *Triptych – August 1972*

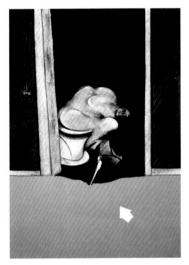

84
Triptych, May – June 1973, 1973
Oil on canvas
Triptych, each panel:
198 × 147.5 cm (78 × 58 in)
Private collection

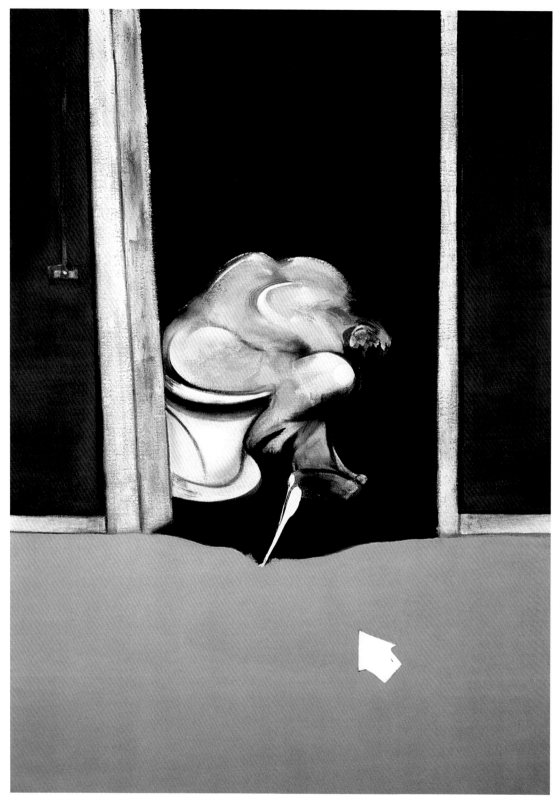

Left panel – *Triptych, May – June 1973*

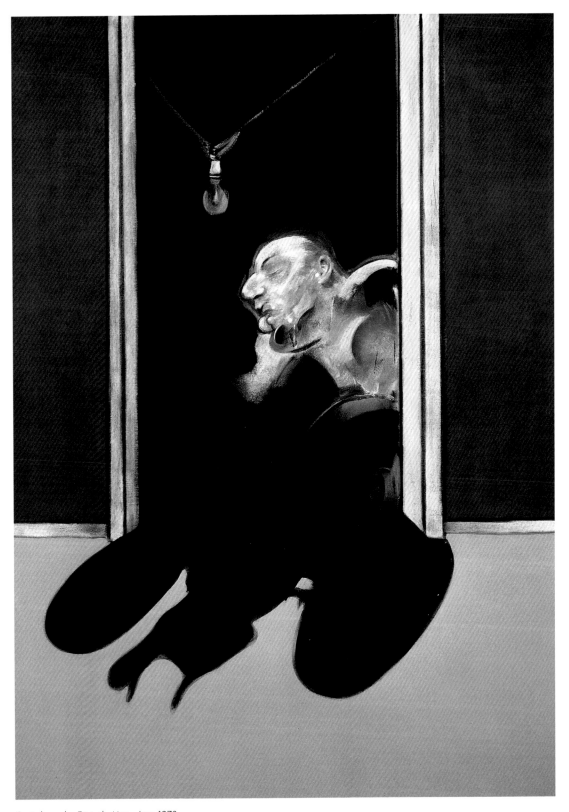

Central panel - *Triptych, May – June 1973*

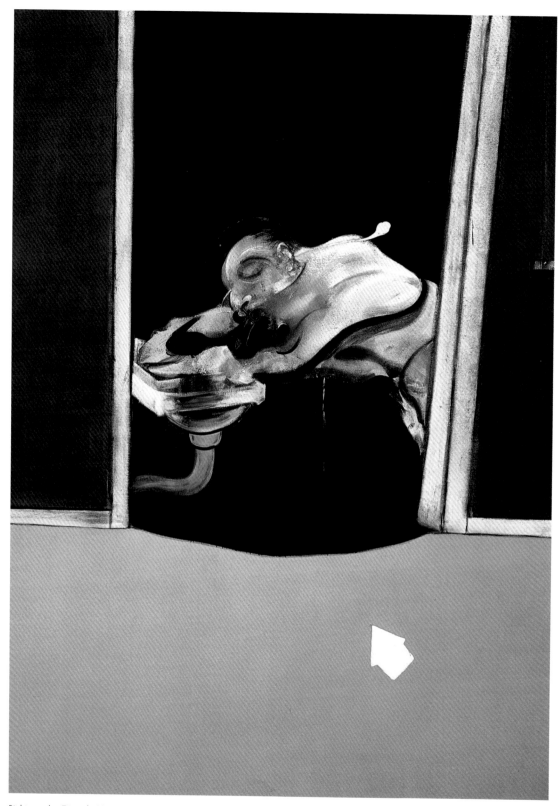

Right panel – *Triptych, May – June 1973*

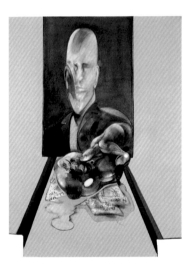

85
Triptych, 1976
Oil on canvas
Triptych, each panel:
198 × 147.5 cm (78 × 58 in)
Private collection

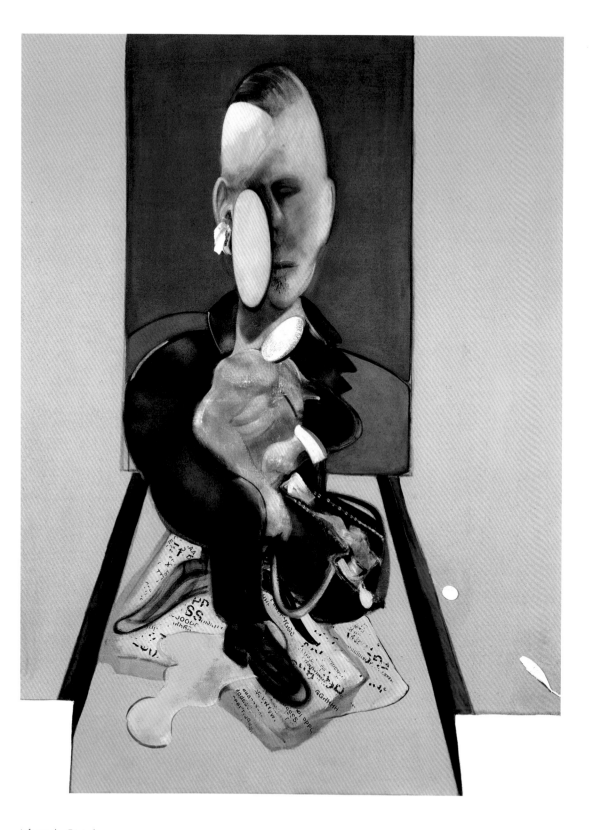

Left panel – *Triptych*

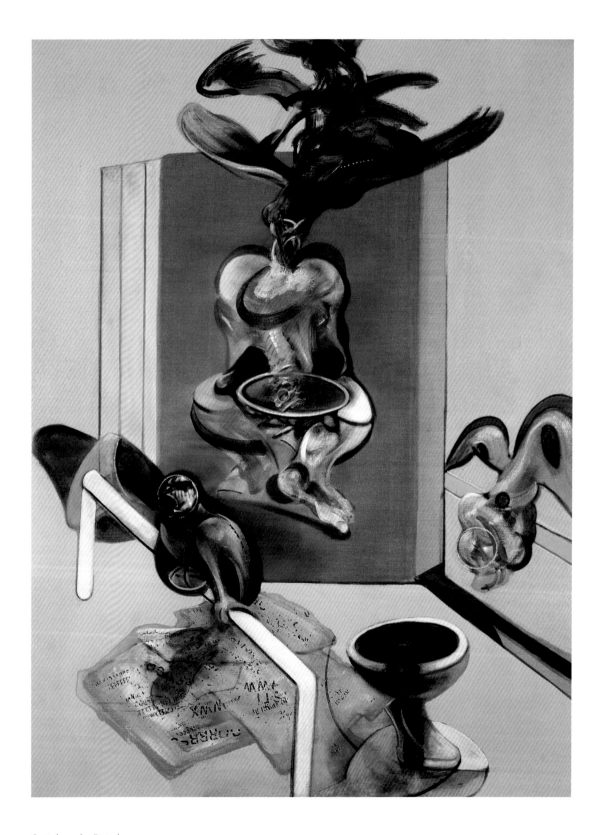

Central panel – *Triptych*

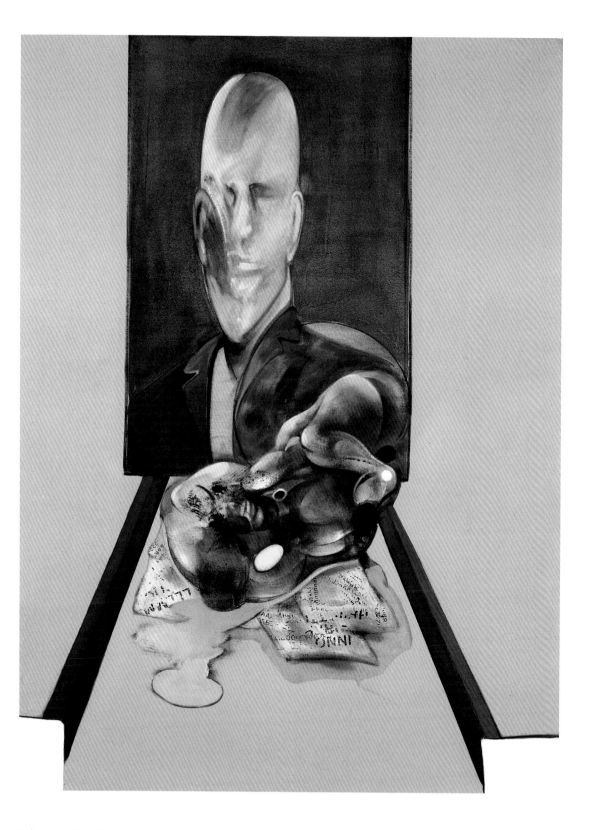

Right panel – *Triptych*

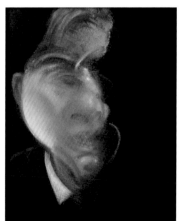 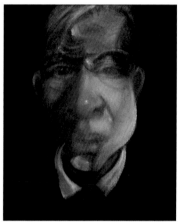 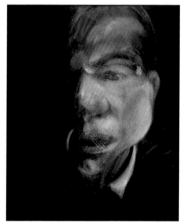

86
Three Studies for a Self-Portrait, 1979–80
Oil on canvas
Triptych, each panel:
37.5 × 31.8 cm (14 ¾ × 12 ½ in)
The Metropolitan Museum of Art, New York

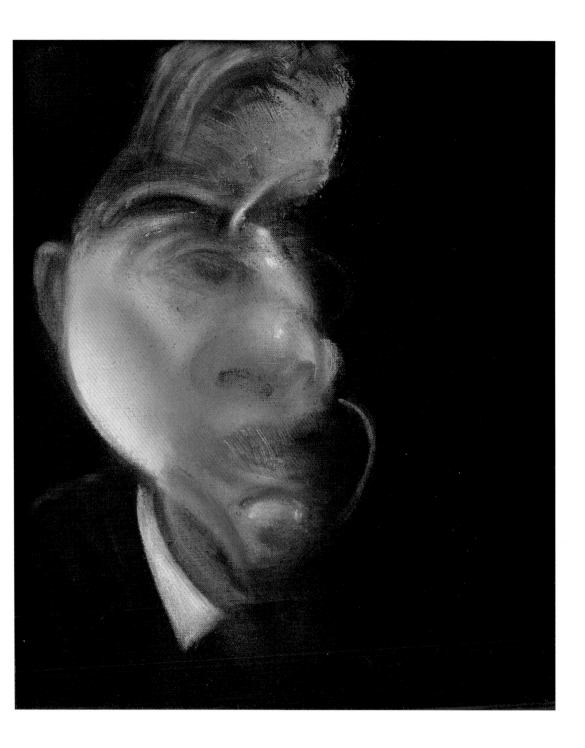

Left panel – *Three Studies for a Self-Portrait*

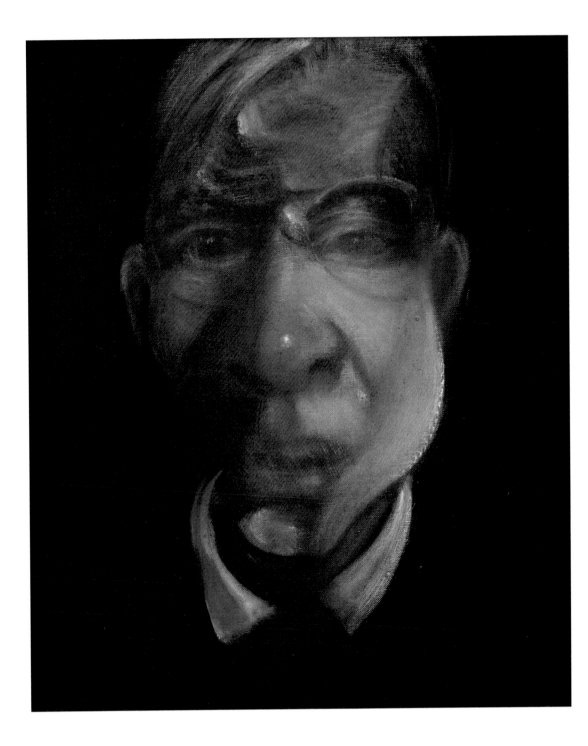

Central panel – *Three Studies for a Self-Portrait*

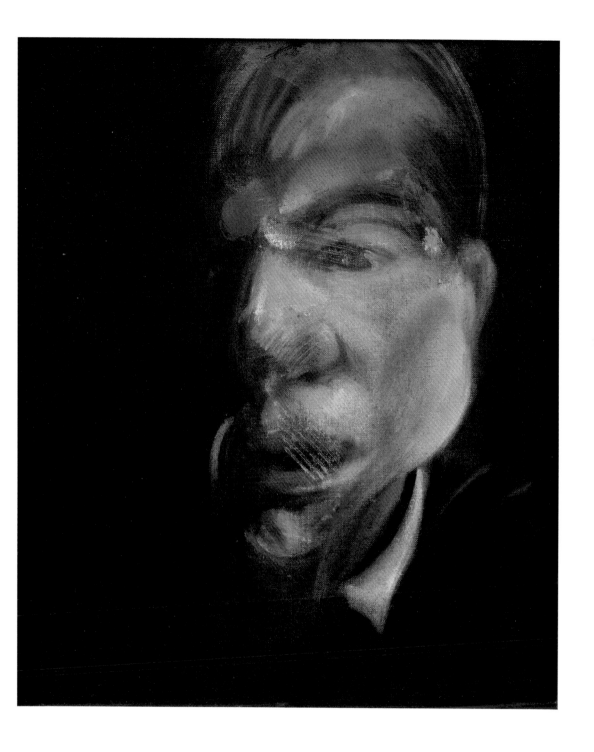

Right panel – *Three Studies for a Self-Portrait*

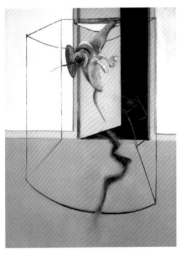
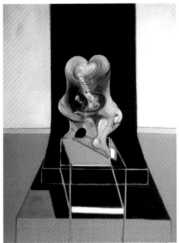
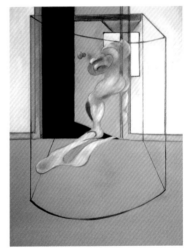

87
Triptych Inspired by the Oresteia of Aeschylus, 1981
Oil on canvas
Triptych, each panel:
198 × 147.5 cm (78 × 58 in)
Astrup Fearnley Museet, Oslo

Bacon remarked on this painting: 'I have been stimulated by reading great literary texts, like Greek tragedies, particularly Aeschylus, or Shakespeare, but not directly influenced ... Reading them can make me want to produce something myself; it's a sort of excitement, perhaps even like sexual excitement ... Painting has nothing to do with illustration.'

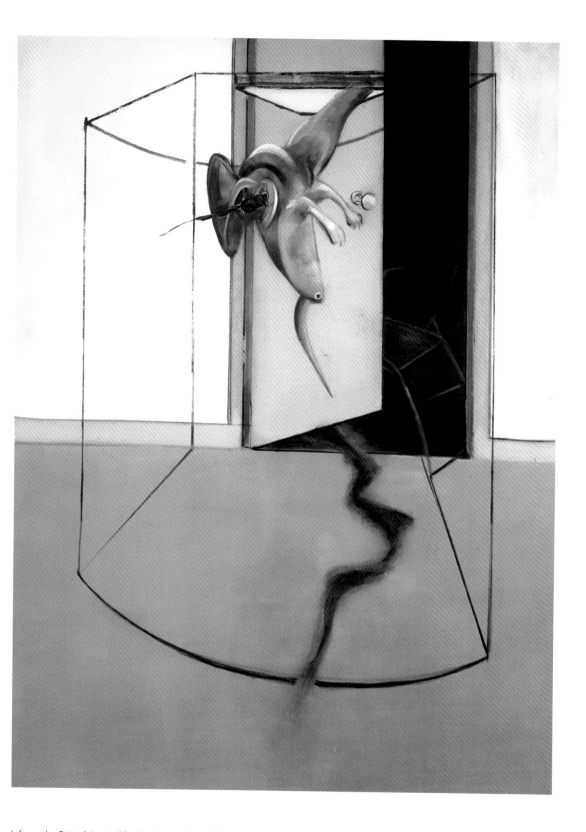

Left panel – *Triptych Inspired by the Oresteia of Aeschylus*

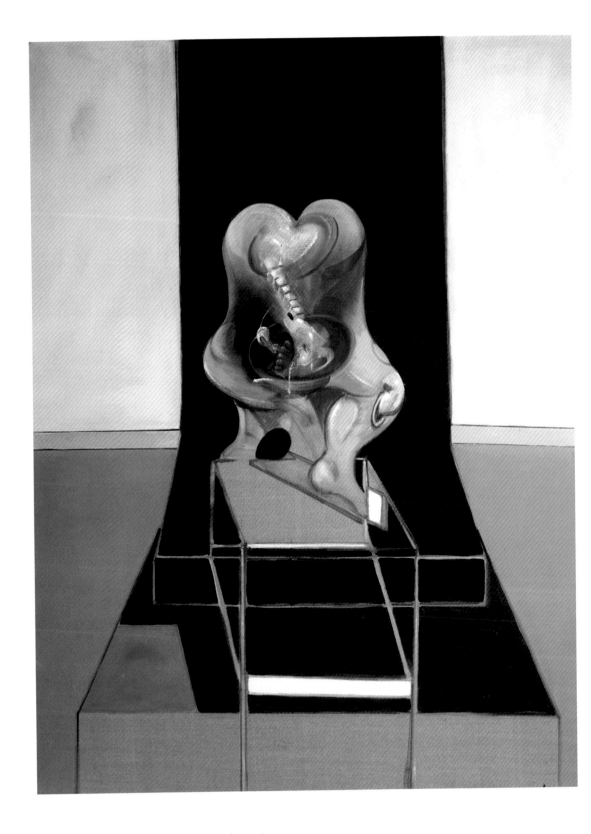

Central panel – *Triptych Inspired by the Oresteia of Aeschylus*

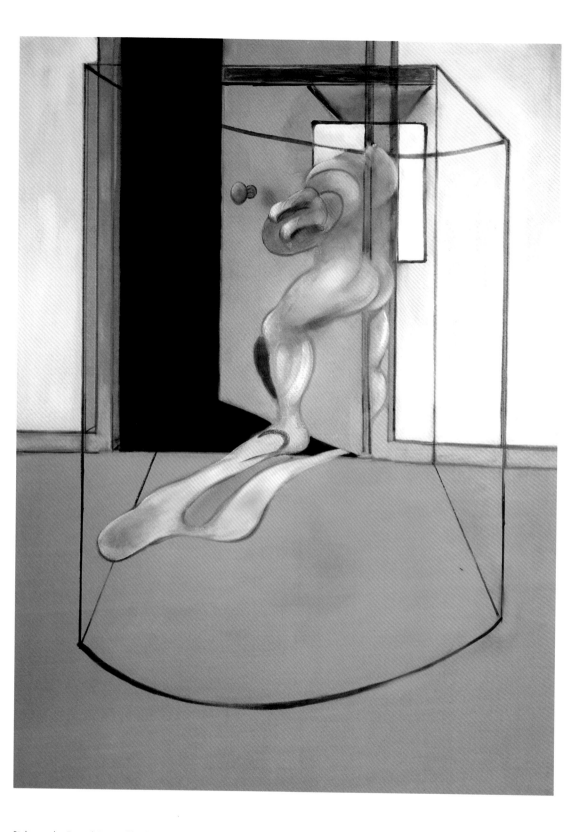

Right panel – *Triptych Inspired by the Oresteia of Aeschylus*

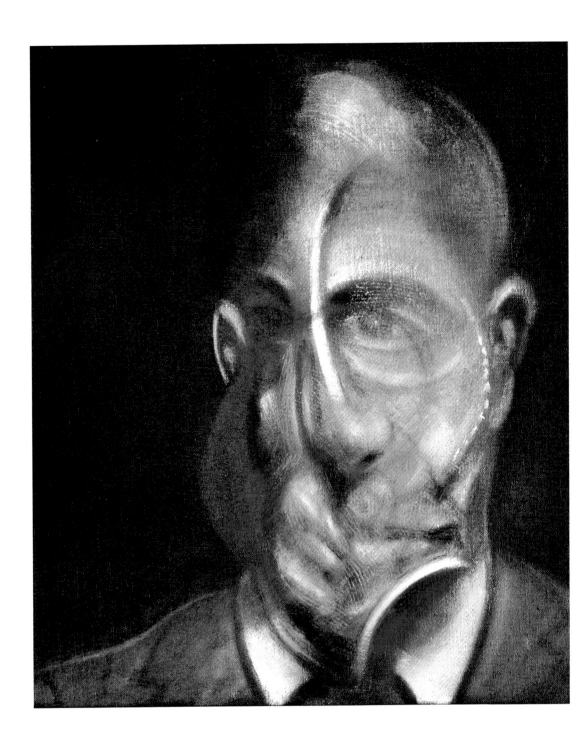

88
Portrait of Michel Leiris, 1976
Oil on canvas
34 × 29 cm (13 ⅜ × 11 ⅜ in)
Centre Pompidou, Paris

In connection with this portrait of his writer friend,
Bacon remarked: 'I'm always hoping to deform
people into appearance ... For instance, I think
that, of those two paintings of Michel Leiris, the
one I did which is less literally like him is in fact
more poignantly like him.'

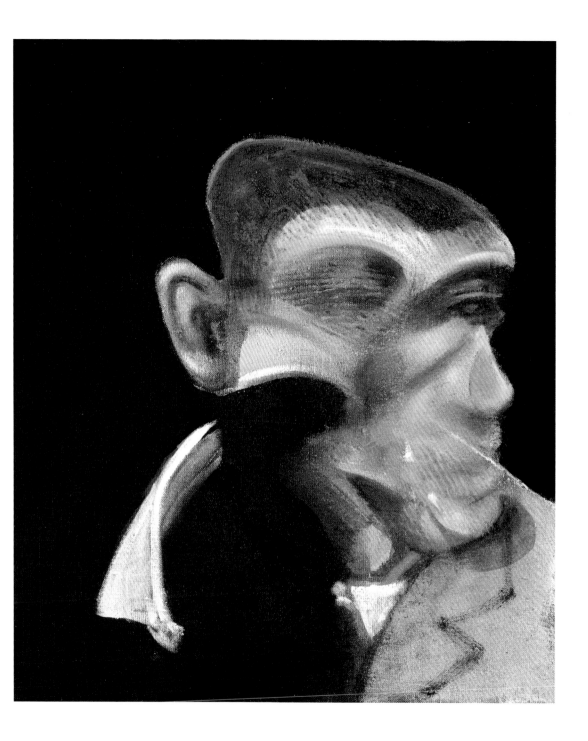

89
Study for a Portrait of John Edwards, 1989
Oil on canvas
35.5 × 30.5 cm (14 × 12 in)
Private collection

 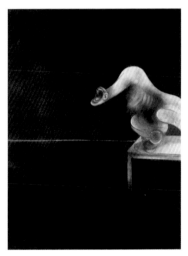

90
Second Version of Triptych 1944, 1988
Oil and acrylic on canvas
Triptych, each panel:
198 × 147.5 cm (78 × 58 in)
Tate, London

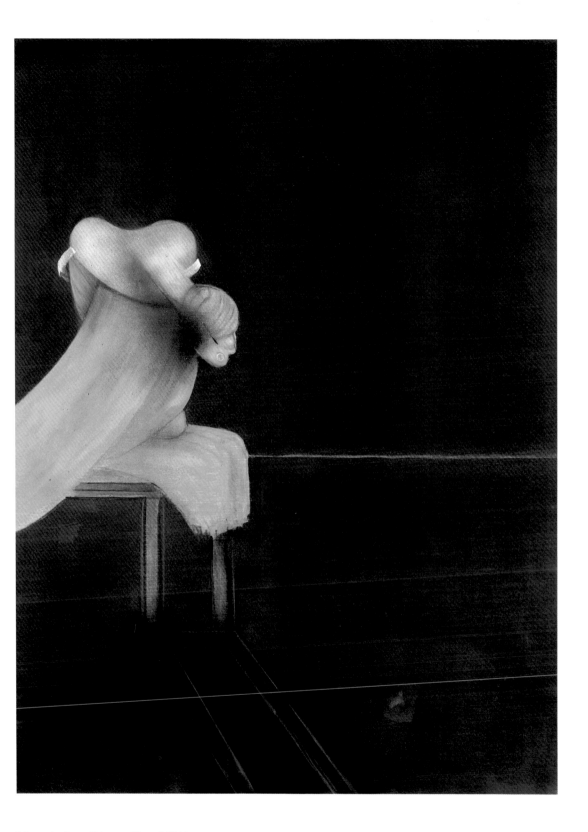

Left panel – *Second Version of Triptych 1944*

Central panel – *Second Version of Triptych 1944*

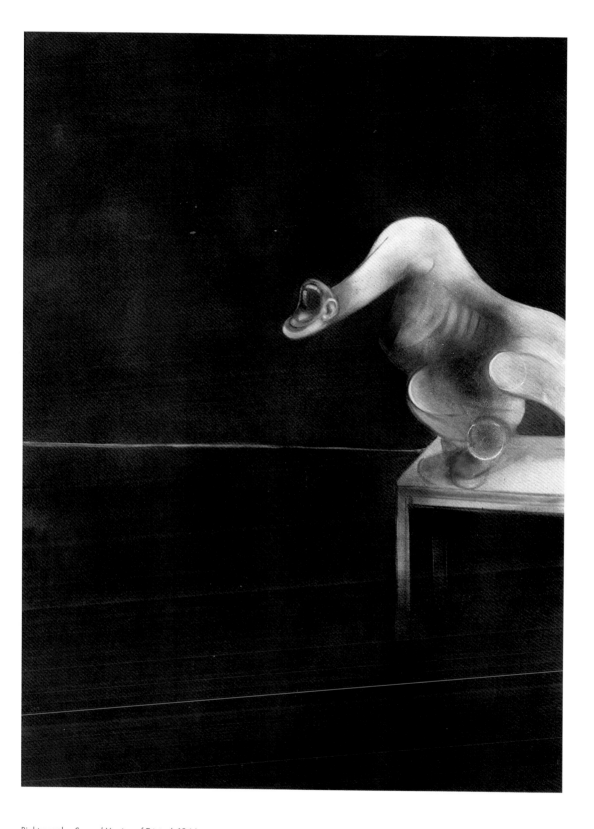

Right panel – *Second Version of Triptych 1944*

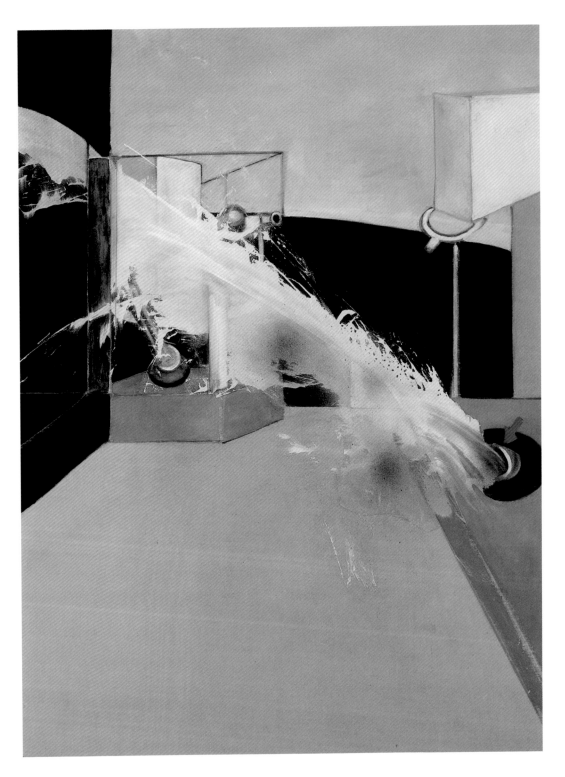

91
Jet of Water, 1988
Oil on canvas
198 × 147.5 cm (78 × 58 in)
Private collection

92
Blood on Pavement, c.1988
Oil on canvas
198 × 147.5 cm (78 × 58 in)
Private collection

FOCUS ⑩

BACON'S STUDIO

In 1961 Bacon acquired a property in Reece Mews, South Kensington, London, near the Victoria and Albert Museum. It consisted of modest living quarters and a space which, with the installation of traditional natural lighting in the roof, could function as a painting studio [93], albeit an impractically small one given that Bacon started producing monumental triptychs the following year and was never able to step back and view the entire works properly. He subsequently bought properties in London and Paris, but found that he could not work in them. The Mews studio suited him. Like previous studios, it soon became extremely messy as magazines, catalogues and photographs accumulated on the floor, trampled upon and spattered with paint, while paint tests proliferated on the walls and door. Yet Bacon found this environment conducive to the creation of paintings in which spontaneity of invention and mark-making were eventually subjugated to an overall pictorial order. As he contemplated them in progress, the pictures gained value and intensity from the cacophony of their initial surroundings, which represented in some sense the flux and randomness of everyday experience. To paraphrase the account of the creative process in 'The Circus Animals' Desertion' by William Butler Yeats, one of his favourite poets, it perhaps felt to Bacon as if commonplace, autobiographical themes – 'the foul rag-and-bone shop of the heart' – were being transfigured and transcended within the forming of 'masterful images'. Bacon explained his attitude to the studio:

> There are two sides to me. I like very perfect things, for instance. I like perfection on a grand scale. In a way I would like to live in a very grand place. But as in painting you make such a mess,

I prefer to live in the mess with the memories and the damage left with one. I think we all have this double side to us. One likes disorder and one likes order. We have to battle for order.

One suspects that Bacon would have been horrified that the entire contents of his studio – the books, notebooks, photographs, unfinished and worked as well as slashed canvases, painting materials and so on that happened to survive – were carefully conserved and catalogued after his death. He might equally have been horrified that the studio itself was faithfully reconstructed in all its squalor at the Hugh Lane Gallery in Dublin, functioning as a research centre, tourist attraction and shrine to Bacon's genius, reclaimed by the city of his birth.

The studio is just one of several sources of new information about Bacon that have emerged since 1992. Various correspondences with friends and dealers have been published. Other friends disclosed that they had been given by the artist fascinating clusters of drawings on paper, a type of work Bacon had always denied making when proclaiming the spontaneity of his paintings. Important pictures that he had abandoned turned out to have survived, such as his 1950 *Study after Velázquez* [53]. Moreover, art historians who were not under the sway of Bacon's powerful personality have begun to explore alternative approaches to his work. In the future, he may appear a very different artist from how he looks today. Bacon himself was realistic enough to concede the test of time: 'No artist knows in his own lifetime whether what he does will be the slightest good, because I think it takes at least seventy-five to a hundred years before the thing starts to sort itself out from the theories that have been formed about it.'

93
Bacon's studio,
Reece Mews,
London

CHRONOLOGY

1909

Francis Bacon is born in Dublin on 28 October into an upper middle-class English family, the second of the five children of Christina Firth, a steel heiress, and Edward Bacon, a racehorse trainer and former army officer. His childhood is divided between Ireland and England.

1926

Now based in London, Bacon begins to live openly as a homosexual, free from his father's censure.

1927

Bacon travels to Berlin and Paris, and spends three months in Chantilly improving his French. Impressed by a Picasso exhibition at the Galerie Paul Rosenberg, he begins to draw and paint. Back in London, he settles in South Kensington, then Chelsea.

1929-38

Bacon works as a furniture and interior designer, receiving several commissions. He organizes his first solo show of paintings at Transition Gallery in 1934, but is disappointed by the lack of sales. This is followed by his rejection from the International Surrealist Exhibition in 1936. He is included in 'Young British Painters', a 1937 exhibition co-organized with his painter friend Roy de Maistre and Eric Hall, a businessman and local politician. Scant work and biographical details from this period survive.

1939-45

Bacon mostly lives in London during World War II; he is exempt from military service but works as an air raid warden until forced to stop because of his asthma. Around 1942 he spends time in Hampshire, before moving into a new studio at 7 Cromwell Place, South Kensington, London, where he gains a renewed commitment to his art. He becomes close to painter Graham Sutherland, and meets Lucian Freud and other artists clustered around the collector Peter Watson. Artist Isabel Rawsthorne, painter and photographer Peter Rose Pulham, and writer and editor Sonia Orwell also become long-term friends.

1945-6

The paintings Bacon would come to see as the real beginning of his art – such as *Three Studies for Figures at the Base of a Crucifixion* and *Figure in a Landscape* – are shown at the Lefevre Gallery. His reputation as an artist who crystallizes the horror of the human condition begins to evolve.

1946-8

The sale of *Painting* to his future dealer at the Hanover Gallery, Erica Brausen, allows Bacon to live in the south of France, an escape from the poverty and dreariness of post-war London, devoting more energy to gambling than to his art. In 1948 *Painting* is sold to the Museum of Modern Art, New York.

1949

Bacon's first post-war solo exhibition is staged at the Hanover Gallery, showing the *Heads* series. It generates supportive reviews from critics such as Robert Melville and David Sylvester. His fascination with photographs and penchant for improvising (and often destroying) his paintings attract comment.

1950–62

He makes several trips to southern Africa to visit family, and to Morocco, where homosexuality is more tolerated than in Britain. He develops a relationship with a former Royal Air Force pilot, Peter Lacy, and befriends American writers William Burroughs and Allan Ginsberg.

1953

A display of his paintings based on pope imagery at Durlacher Brothers marks his first show in New York.

1954

Bacon, Ben Nicholson and Lucian Freud show in the British Pavilion at the XXVII Venice Biennale. He visits Italy but does not attend the Biennale opening, nor go to see Velázquez's *Portrait of Pope Innocent X* in Rome.

1957

Bacon's show at the Hanover Gallery features his variations on a Van Gogh self-portrait. The pictures herald the brighter palette of his future work.

1958

Bacon transfers from the Hanover Gallery to Marlborough Fine Art, who begins to manage his career on a more professional basis, collaborating on major museum shows and staging regular shows at their galleries.

1959

His gallery persuades him to spend a few months in St Ives, Cornwall. His work is included in the V Bienal de São Paulo and documenta II, Kassel.

1961

After several years drifting between abodes and studios, he settles in Reece Mews, South Kensington, where he lives and works for the rest of his life.

1962

The Tate organizes a major retrospective, for which Bacon produces *Three Studies for a Crucifixion,* the first of the many large-scale triptychs that subsequently dominate his output. Bacon's signature style sets forms and painterly textures against flat, boldly coloured grounds. Portraiture becomes a key subject. He records the first of many interviews with Sylvester. His lover Peter Lacy dies in Tangier.

1963

A show at the Solomon R. Guggenheim Museum, New York, confirms his international reputation. He begins a relationship with George Dyer, a petty East End crook.

1964

Ronald Alley's *Catalogue Raisonné* of Bacon's work to date is published.

1965

Bacon meets writer Michel Leiris at a Giacometti exhibition at the Tate. Leiris becomes a close friend. He later translates the Sylvester interviews.

1968

Bacon makes his first visit to New York for his exhibition opening at the Marlborough-Gerson Gallery.

1971

The large retrospective at the Grand Palais in Paris is a great honour for a living artist, especially a British one, and for Bacon a crowning moment in his career. Dyer's suicide on the eve of the opening, in their hotel, prompts a remarkable sequence of memorial triptychs over the next three years.

1974

Bacon acquires a flat in Paris and thereafter makes regular visits there, spending time with close friends such as Michel Leiris.

1975

The Metropolitan Museum of Art holds a retrospective. Bacon travels to New York and meets artists such as Andy Warhol and Robert Rauschenberg, whose work he clearly likes. A book of interviews with Sylvester is published and expanded in 1980 and 1987. Bacon forges an important friendship with John Edwards, his eventual heir.

1977–8

Bacon has exhibitions in Paris, Mexico City, Madrid and Barcelona. His work increasingly focuses on portraits and self-portraits.

1985

Bacon's second big retrospective at the Tate also travels to Stuttgart and Berlin. He selects his favourite Old Master pictures from the National Gallery collection for the exhibition 'The Artist's Eye'. He is now seen as a highly individual painter, but also as an influential figure in 'The School of London', a loose group encompassing Freud, Frank Auerbach, Leon Kossoff, Michael Andrews and R.B. Kitaj, who share commitments to figurative subject matter, at a time when more abstract or conceptual approaches are prevalent.

1988

He has a much admired retrospective at the Central House of Artists of the New Tretyakov Gallery, Moscow, his first show behind the Iron Curtain.

1989

A major exhibition tours the Hirshhorn Museum, Smithsonian Institution, Washington DC; the County Museum of Art, Los Angeles and the Museum of Modern Art, New York.

1992

Francis Bacon dies from a heart attack on 28 April at the age of eighty-two, during a visit to Madrid.

FURTHER READING

Dawn Ades and Andrew Forge, *Francis Bacon* (exh. cat., Tate, London, 1985)

Ronald Alley and John Rothenstein, *Francis Bacon* (London, 1964)

Ernst Van Alphen, *Francis Bacon and the Loss of Self* (London, 1992)

Michel Archimbaud, *Francis Bacon: In Conversation with Michel Archimbaud* (London, 1993)

Anne Baldassari, *Bacon – Picasso: The Life of Images* (Paris, 2005)

Andrew Brighton, *Francis Bacon* (London, 2001)

Richard Calvocoressi and Martin Hammer, *Francis Bacon: Portraits and Heads* (exh. cat., National Galleries of Scotland, Edinburgh, 2005)

Margarita Cappock, *Francis Bacon's Studio* (London, 2005)

Hugh Davies, *Francis Bacon, The Papal Portraits of 1953* (exh. cat., Museum of Contemporary Art, San Diego, 2001)

Hugh Davies and Sally Yard, *Bacon* (New York, 1986)

Barbara Dawson and Martin Harrison (eds), *Francis Bacon: A Terrible Beauty* (exh. cat., The Hugh Lane Gallery, Dublin, 2010)

Gilles Deleuze, *Francis Bacon: The Logic of Sensation*, Daniel W. Smith, trans. (London and New York, 2005)

Daniel Farson, *The Gilded Gutter Life of Francis Bacon* (London, 1993)

Matthew Gale, *Francis Bacon: Working on Paper* (exh. cat., Tate, London, 1999)

Matthew Gale and Chris Stephens (eds), *Francis Bacon* (exh. cat., Tate, London, 2008)

Martin Hammer, *Bacon and Sutherland* (New Haven and London, 2005)

Martin Hammer, *Francis Bacon and Nazi Propaganda* (London, 2012)

Martin Harrison, *In Camera – Francis Bacon, Photography, Film and the Practice of Painting* (London, 2005)

Martin Harrison, *Francis Bacon: New Studies: Centenary Essays* (Göttingen, 2009)

Martin Harrison and Rebecca Daniels, *Francis Bacon: Incunabula* (London, 2008)

Michel Leiris, *Francis Bacon: Full Face and In Profile* (London, 1983)

Michael Peppiatt, *Francis Bacon: Anatomy of an Enigma* (London, 1996, revised edn 2008)

Michael Peppiatt, *Studies for a Portrait* (New Haven and London, 2008)

John Russell, *Francis Bacon* (London, 1971; revised and updated 1993)

Barbara Steffen (ed.), *Francis Bacon and the Tradition of Art* (exh. cat., Kunsthistorisches Museum, Vienna, 2003)

David Sylvester, *Interviews with Francis Bacon* (London, 1993)

David Sylvester, *Looking Back at Francis Bacon* (London, 2000)

Visual Culture in Britain, 10 (November 2009) – special issue 'Bacon Reframed'

Armin Zweite (ed.), *Francis Bacon: The Violence of the Real* (London, 2006)

PICTURE CREDITS

LIST OF WORKS